Look!

Library of Congress Cataloging-in-Publication Data is available upon request from the Library of Congress

Editor-in-Chief: Sarah Touborg
Senior Managing Editor: Lisa Iarkowski
Editorial Assistant: Jacquie Zea

Manufacturing Buyer: Sherry Lewis
Marketing: Brandy Dawson

Credits and acknowledgments from other sources and reproduced, with permission, in this textbook appear on page 176

Pearson Education LTD.
Pearson Education Australia PTY, Limited
Pearson Education Singapore, Pte. Ltd
Pearson Education North Asia Ltd

Pearson Education, Canada, Ltd
Pearson Educación de Mexico, S.A. de C.V.
Pearson Education-Japan
Pearson Education Malaysia, Pte. Ltd

This book was designed and produced by
Laurence King Publishing Ltd., London
www.laurenceking.co.uk

Every effort has been made to contact the copyright holders, but should there be any errors or omissions, Laurence King Publishing Ltd would be pleased to insert the appropriate acknowledgment in any subsequent printing of this publication.

Design: Andrew Lindesay
Picture Research: Sue Bolsom

Front cover: Detail of Titian, *Venus of Urbino*, 1538-1539. Oil on canvas, 3 ft. 11 in. x 5ft. 5 in. Uffizi Gallery, Florence. © Quattrone, Florence.

10 9 8 7 6 5 4 3 2 1
ISBN 0131745050

Anne D'Alleva

Look!

The Fundamentals of Art History

Prentice Hall Inc. Upper Saddle River, NJ. 07458

Contents

Chapter 6 Art history's own history

Acknowledgments

This book has been both a long and a short time in the making. Much of the insight presented here I learned— the hard way—as an undergraduate and graduate student of art history. Fine colleagues at Columbia University, the University of St Thomas, and the University of Connecticut have contributed to my growth as a teacher and communicator. In particular, I would like to acknowledge conversations with John Farmer, Amanda Badgett, and Diana Linden for the inspiration they have offered me. Kelly Dennis wisely suggested that I address the controversies that art can generate, a topic that I added to Chapter 3. I should also like to thank the reviewers for their very helpful assessment of how the revised edition could be improved: W Jackson Rushing III, University of Texas at Dallas; Marian Mazzone, College of Charleston; Anne Betty Weinshenker; Asa Simon Mittman, Arizona State University; Catherine E. Karkov, Miami University.

A number of people have helped with *Look!* in various ways. First I should acknowledge the steady stream of students who have asked questions in class, visited my office, and stopped me in the hall, rightfully demanding that I explain things more clearly and give them better tools for learning. My thanks are also due to the students who permitted me to quote from their papers. Meghan Dahn and Alexis Begin both gave the first edition of this text a thorough reading, and their trenchant criticisms greatly improved it. Along with Philip Buntin, Meghan also assisted with the compilation of the endmatter, as did Michael Young, the University of Connecticut's art librarian. Elisabeth Parcinski provided invaluable clerical and editorial help in preparing the second edition, which would not have appeared without her. The terrific professionals at Laurence King Publishing deserve a great deal of recognition for their hard work on this book: Kara Hattersley-Smith, Donald Dinwiddie, Michael Bird, Sue Bolsom and Andrew Lindesay. Gary Morris has been an essential supporter of this project, and I am grateful for his help.

Finally, I must thank my family—parents, sisters, and nephew—for their encouragement. My partner Cathy Bochain has shown unswerving support for me and my work, even under the most difficult circumstances. Both she and our son, James, make life a joy.

I first wrote *Look!* to help undergraduates—like you— navigate their way through introductory art history surveys. In this revised second edition, I have returned to the subject, further refining and clarifying it as a guidebook. As you probably already realize, introductory art history can be simultaneously exciting and challenging for both instructors and students. These courses cover a dazzling array of artworks from prehistory to the present across a range of cultures and offer provocative new ways to think about key moments in human history. Unfortunately, precisely because these courses are so packed with interesting material, we instructors don't always spend enough time teaching our students how to deal with that material either conceptually (in learning to think like art historians) or practically (in terms of the papers and exams that students must produce).

Improving on the first edition's efforts, this second edition of *Look!* attempts to do both these things. It starts out by providing a basic introduction to art history as an academic discipline. It then introduces the fundamental methods of art history: the formal and contextual analysis of works of art. It goes on to provide guidelines to writing good papers and exams, and provides suggestions on effective note-taking. Finally it includes a brief overview of the history of art history, so that you'll understand how the discipline evolved and why it asks the kind of questions that it does.

I've tried to orient *Look!* toward the kinds of visual images and issues discussed in introductory classes. You'll notice that most of the illustrations, or similar examples, also appear in one or more of the major survey texts used in such courses (including Honour and Fleming, Janson, Gardner, Stokstad, and Abrams). The sample paper assignments and exam questions included here come from material I've used in my own courses.

The examples of student writing have been only lightly edited for grammar and length: these are real-life responses to real-life exams and paper assignments.

Because Look! is a handbook and resource, it's not necessarily a book that you'll read through from beginning to end. There are lots of different ways to use it effectively, and I'll offer a few suggestions here:

Chapter 1: Introducing Art History provides a basic introduction to art history as an academic discipline. It's a good idea to read this fairly early on in your course—perhaps in conjunction with your instructor's introductory classes—so you'll be firmly grounded in the goals of the course and the discipline.

I also recommend reading **Chapter 2: Formal Analysis** and **Chapter 3: Contextual Analysis** early in your studies. I have in this new edition divided this important discussion into two chapters, providing clear and distinct introductions to these two basic art-historical methods. You'll see your instructors performing both kinds of analysis in class; these chapters show you various ways to develop these skills so that you can use them in class discussion and in writing papers and exams.

Save **Chapter 4: Writing Art-History Papers** until you're preparing to start your first paper assignment. You'll probably consult this chapter repeatedly as you're working on the paper.

You may want to read the parts of **Chapter 5: Navigating Art-History Examinations** that deal with note-taking early in your course. Read the parts about exams when you're starting to review images. (By the way, I recommend reviewing images every week, not just in the few days before an exam.)

Chapter 6: Art History's Own History is the kind of chapter you'll read or browse through when you're not under time pressure to study for an exam or read a paper (unless, of course, you're procrastinating . . .). It gives you a larger perspective on the discipline of art history, which you may find especially interesting if you're thinking about majoring or minoring in art history.

However you approach this book, you should read

actively, picking and choosing the parts of the text that are useful to you. Art history is about looking critically and analyzing what you see, and this book is no exception. My sense is that different students, depending on their academic backgrounds, will use the book in different ways. Although some parts of it may seem simple to you, keep reading, because you're likely to come upon something you didn't know.

The book's structure is simple. Each chapter starts with a short introductory paragraph that provides a brief list of the chapter's main aims and ends with a short concluding paragraph that summarizes what you should have learned. Throughout the book, you'll find boxed texts that take up specific points in depth. You don't have to read these boxed texts to make sense of the main text, but they may be interesting and helpful anyway. The captions to the photographs provide basic information and sometimes more extended comments about the pieces illustrated. Again, these comments may be interesting and informative, but you don't have to read them to make sense of the image or the main text. The bibliography lists works that I've used in writing this book, an also some additional works that you may find helpful. In addition to the standard glossary and index, there's also a table of parallel illustrations in art-history surveys showing where to find the illustrations in this book, or comparable images, in the major art-history textbooks.

Good luck with your work! Art history has been a wonderful (and, yes, sometimes frustrating) part of my life since I was a first-year college student. I hope you'll experience some of the same rewards and pleasures that I have had as an art historian.

Chapter 1
Introducing art history

If you don't know where you're going, you'll end up somewhere else.

Yogi Berra, baseball player (b. 1925)

This chapter will introduce you to art history as an academic discipline. It distinguishes the aims and methods of art history from related disciplines like anthropology and aesthetics. It also attempts to answer two questions that are more complicated than they appear at first glance: What is art? and What is history?

What do art historians do? The object of art history

Art historians do art. But we don't make it, we study it. We figure it out. We try to understand what artists are expressing in their work, and what viewers perceive in it. We try to understand why something was made at the time it was made, how it reflected the world it was made in, and how it affected that world. We talk about individual artists and their goals and intentions, to be sure, but also about patrons, viewers, and the kinds of institutions, places, and social groups in which art is made and circulates—whether that's an art school, temple, or government agency.

What is "art"?

"Art" is one of those words that people use all the time but that are actually hard to define. All sorts of cultural and political values determine what gets included or not

included under this term, which makes it difficult for people to agree on precisely what art is. However, it's important to make the attempt as a first step in discussing what art history, as a discipline, actually does.

This process of definition is complicated for two reasons: first, the term "art" has not been around very long in Western culture; and second, there is rarely an exactly corresponding term in other cultures. In Europe, the term "art" as we commonly understand it today emerged in the Renaissance—earlier periods had no direct equivalent for it. The Greek philosopher Plato (c. 428–c. 348 BCE), for example, used the term *mimesis*, which means imitation, to talk about painting and sculpture. In ancient Greek, *demiourgos*, "one who works for the people," can refer to a cook as well as a sculptor or painter. Similarly, over a thousand languages are spoken in Africa, and over six hundred in Papua New Guinea, but none of them includes a precise translation for the term "art."

In defining this term, many people today would start from an essentially post-Renaissance definition of art as a painting, sculpture, drawing, print, or building made with unusual skill and inspiration by a person with specialized training to produce such works. Most people would agree, according to this definition, that the decoration of the Sistine Chapel ceiling by Michelangelo (1475–1564) is art (even if they don't particularly like it themselves). What belongs in this category of "art" does shift over time. It often happens that objects excluded from this category at one time now easily qualify as art. In the nineteenth century, for example, people commonly excluded the sculpture, paintings, and architecture of Africa, the Pacific, and other regions of the world because they (wrongly) regarded these arts as "primitive" or inferior to Western art, not simply different from them.

One problem with this definition of "art" is that it consistently leaves out a lot of other things that people make and do. For example, it excludes useful objects like baskets or ceramic pots made by people with craft skills but with no professional training as artists. This kind of

work is sometimes called "folk art" or "low art," to distinguish it from "high art" such as the Sistine Chapel. From this perspective, the category "art" doesn't include many things historically made by women in Europe and North America, including embroidery, quilts, and hand-woven textiles. At the same time, people sometimes use this definition of "art" to exclude a lot of modern art, which they don't think is characterized by sufficient skill, seriousness, or conceptual complexity. (Maybe you've had the experience of being in a modern art gallery and hearing someone say—or even saying yourself—"A child could make that! That's not art.")

Although some people are perfectly happy to circle the wagons and exclude anything from the category "art" that doesn't fit a fairly narrow definition, that's not a productive attitude for a scholar to take. Excluding things from a category is often a way to devalue them and to justify not engaging with them in a serious way. As I see it, "art" should be a flexible, inclusive category—a term and idea that get us looking at and thinking critically about all the different kinds of things people make and do creatively.

A working definition of art

There are many different ways to define art. But for the purposes of this book, I'll define art as potentially any material or visual thing that is made by a person or persons and that is invested with social, political, spiritual, and/or aesthetic value by the creator, user, viewer, and/or patron. My definition of art includes the Sistine Chapel ceiling, to be sure, but it also includes such things as a wood figure from Papua New Guinea, a quilt, an Ottoman ceramic pitcher, and an advertising poster. It includes ephemeral (non-permanent) things such as a masquerade costume made from leaves by the Bwa people of Burkina Faso in west Africa. Using the word "thing" here doesn't mean that a work of art has to be a concrete object like a marble sculpture—a film or a performance can also be art in this sense. All these things are made with special skills and with great attention to

their appearance, although most would be excluded from the traditional category of "high art." In my definition, art may have economic value but not economic value alone. A pile of pine logs on a flatbed truck has economic value but isn't in the category of art—unless, of course, the loggers deliberately arranged the logs in a certain way that carries social/political/spiritual/ aesthetic meaning.

Remember that I'm not using the term "art" because it's universal or inherent to the objects of our study, or because I want to create hierarchies or make value judgements. Many artists and art historians today reject the idea that a work of art is, by definition, an inherently "higher" or privileged type of object. This is the idea that Barbara Kruger (b. 1945) critiques when she tells her viewers "You invest in the divinity of the masterpiece" (Figure 1.1). Rather, I use a broad definition of art because regarding things as "art"—putting them in that category—helps me ask better questions and opens up certain ways of thinking about them.

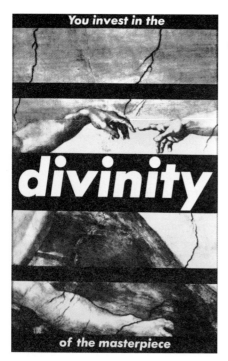

1.1 Barbara Kruger, Untitled (You Invest in the Divinity of the Masterpiece), 1982. Photostat. The Museum of Modern Art, New York.

Kruger's words frame a detail of the Sistine Chapel ceiling (the ultimate masterpiece) that represents God reaching out to endow Adam with life (the ultimate act of creation). Her work critiques the ways that masterpieces are "made:" we as a culture decide to invest aesthetic and other kinds of value in certain works even as we devalue others.

Though you may find the concept of art that I've outlined here challenging, you probably won't find it particularly hard to categorize the images included in this book as art. Most of the illustrations come from the major art-history survey textbooks, which focus primarily on well-known artworks that have been studied and considered important for some time.

What is "history"?

It may seem silly to ask this question, but bear with me here. Our word "history" comes directly from the Latin *historia*, which means "inquiry" as well as "history." The *Webster's Dictionary* definition goes like this:

1. TALE, STORY

2. *a*: a chronological record of significant events (as affecting a nation or institution) often including an explanation of their causes *b*: a treatise presenting systematically related natural phenomena *c*: an account of a patient's medical background *d*: an established record [a prisoner with a history of violence]

3. a branch of knowledge that records and explains past events [medieval history]

So how do we put these bits and pieces together into the practice that we call history? History is telling tales about the past—it is making stories. These stories are not fictions (although sometimes fiction can tell history). But histories are grounded in the events that happened—they have to be "true" in the sense that they are based on verifiable historical evidence. And yet all historians must confront the challenge of the gaps, omissions, misrepresentations, and inconsistencies in the various documents, objects, texts, and memories comprising the historical record. This is why writing or telling history is an act of interpretation, creative as well as scholarly. Sometimes I think that being a historian is like being a weaver—history isn't a blanket already woven for us, but instead starts from the scraps of yarn that are the remains of a tattered old blanket. We take those bits and pieces of yarn and weave them again into a blanket. It's a new

blanket, but if we're skilled weavers, it will tell us something of what the old blanket was like.

On top of all this, the chronological range of art history sometimes confuses students. How far in the past does art have to be for it to be history? Why is it that some art historians write about contemporary art? As I see it, art historians write about the art of the past, which both is history and tells history. They also write about art of the present that will be the history of this time: it is art that will tell people in the future about this present moment. Of course, contemporary art often has something to tell us, too, about the moment we live in. It can be a risky business, because the winnowing process of history hasn't taken place—artworks of enduring significance have yet to emerge as such. What if the art historian makes a mistake? What if her subject doesn't turn out to be as significant as she thought? There's no easy answer, except to say that, along with this risk, there's excitement, too, in telling the history of contemporary art, precisely because that winnowing process hasn't yet taken place.

Why is art history important?

Why is art history important? This is one of those questions that you tend to ask yourself as you're pulling an all-nighter to study for an exam or write a paper. Why, you may ask in total despair, am I torturing myself with this class . . .

Considered in the light of day, there are several possible answers to that question. Lots of undergraduates take art history simply to fulfil a general education requirement for their degrees. For them it's a completely

utilitarian undertaking. Others study art history to become more cultivated, to possess some of the knowledge—and polish—that they feel an educated person ought to have. These are both legitimate reasons, as far as they go, but I think there are other answers to the question that are much more interesting.

The first is that art history teaches you to think differently. It teaches you to ask interesting questions, to reject standard answers and conventional wisdom, to look beyond surfaces and obvious appearances, to see the nuances and shades of gray in things. Art history will help you develop skills in visual analysis and critical reading; you will learn to build solid arguments, and to express your ideas effectively, both verbally and in writing. This training will not only help you if you want to become an art historian; it will also enhance your ability to practice a lot of different professions.

The second answer is that art history gives us unique access to the past, because history cannot be told only through documents, texts, and words. Human lives are short, but the things people make are enduring, and they give us a sense of what those past lives were like. As the poet Robert Browning said, art is a way of telling essential

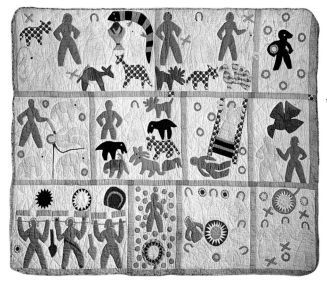

1.2 Harriet Powers, Bible quilt, c. 1886, National Museum of American History, Smithsonian Institution, Washington, D.C.

Harriet Powers (1837–1910) was an ex-slave from Athens, Georgia whose two surviving works are masterpieces of the quilting art and the best surviving early examples of this rich artistic tradition in the southern United States.

truths—of expressing ideas, emotions, viewpoints that sometimes can't be expressed any other way. If you want to know a culture's "truths," then look at its art.

I think there's another good reason to study art history, although people don't talk about it much. Pleasure. The joy of it. Taking a course is hard work, and there's always the grind of exams and paper deadlines. But I hope that at some point in your study of art history you'll experience the sheer joy of being totally absorbed in a work of art, of feeling that you "get" what Michelangelo or Käthe Kollwitz (1867–1945) or a Native American beadworker was trying to do. That you'll experience the excitement of art history "detective work" as you piece together an interpretation, creating a narrative about a work or an artist or culture. That you'll feel awed by a great example of human creativity—and that you'll be stirred to happiness or anger or sorrow by it. Or that you'll be touched by the sense of humanity conveyed in the trace of an artist's hand in a chisel mark on a stone surface or the stitches on a quilt (Figure 1.2).

Now maybe I'm a hopeless romantic, but I believe in the value of such experiences both intellectually and emotionally. As a teacher, I want my courses to change the way students see themselves and see the world—what's the point of spending a semester together if you leave my course with the same ideas, knowledge, and skills going out that you brought into it? I hope you will be open to the possibility of all that your engagement with art history can offer.

Art history and related disciplines

As you'll learn in this book, art history has a distinctive way of going about studying and explaining art. Art historians start from the premise that art isn't just an illustration of the past, but a key element in telling human history. To tell their histories, art historians may employ a wide range of methods, from closely studying works of art themselves to examining archival documents to interviewing artists and patrons. At the same time, many academic disciplines are interested in the

visual and material arts. What makes art history distinctive as an intellectual tradition and scholarly practice, compared with other disciplines?

Art criticism

Art criticism is the practice of evaluating art for its aesthetic and cultural worth, rather than using it to tell history. Over the centuries, many writers, such as Pliny the Elder (23–79 CE) and Giorgio Vasari (1511–1574), mixed art history with art criticism. It was really not until the eighteenth century that the distinctions between the two were clarified. For a long time, art critics tried to establish, or thought they were working with, universal standards of what defines excellence. Very rarely do art critics or their audiences think this today. Like art history, art criticism is widening its scope as ideas about what art is, or what is relevant to art, change.

Sociology

Sociology focuses on the analysis of social groups. The sociology of art explores the function of art in society, both generally and also within particular social groups. Sociologists, for example, might study artists as an occupation group, just as they would truck drivers or surgeons. They tend to focus on the social relationships that produce art and shape its reception, rather than the analysis of the artwork itself. In this way sociology overlaps with anthropology and some branches of art history. Sociology does not focus particularly on "high art:" a sociologist would study family vacation snapshots just as readily as the celebrated photography of Ansel Adams (1902– 1984). As art history broadens its scope to focus less on "high art" there is an increasing overlap between these two academic disciplines. However, sociology's core research methods, including the use of questionnaires and interviews, differ from the methods that art historians typically use. Although art historians working with modern or contemporary art will often engage in interviews, art historians generally emphasize archival work and close examination of the artwork itself.

Anthropology

Anthropology is the study of human beings and their cultures. It includes three main branches: archaeology, physical anthropology, and cultural anthropology. Traditionally, cultural anthropology has primarily focused on small-scale cultures outside Europe, although anthropologists do not consider themselves limited in this way today. Thus anthropology has differed historically from art history, which has focused on the art of large-scale cultures and nations. Anthropology's core method is participant observation (sometimes called "fieldwork"), in which the anthropologist lives in the culture he or she is studying for months or years at a time. This method has of course meant that anthropologists have traditionally studied contemporary cultures. Now that anthropologists often take a more historical interest, while art historians have widened the range of cultures they study and sometimes use participant observation techniques, there is an increasing overlap between these disciplines.

Aesthetics

Aesthetics is a branch of philosophy that seeks to understand several basic questions: What is artistic and natural beauty? What is art? What is the nature of aesthetic judgement? As a formal branch of philosophy, aesthetics dates to the eighteenth century, although philosophers were thinking about these questions long before that. The methodology of aesthetics, and philosophy, is quite distinct from art history. Philosophers working in aesthetics rarely engage in the kind of in-depth contextual analysis that characterizes art history today. Philosophy uses the conceptual case study, in which the examples used to build the argument are essentially hypothetical rather than historical.

Cultural studies

Cultural studies emerged in Britain and the US in the 1950s and 1960s as a rebellion against the narrowness of traditional academic disciplines. The scholar Raymond Williams (1921–1988) defined cultural studies by its

refusal to define culture in isolation from the rest of social life. It often combines methodologies from many disciplines, but certain key themes do emerge. Cultural studies is concerned with the articulation of, and the struggle for, power through and in culture. It tends to focus on disempowered populations, such as the working class, people of color, or women. All sorts of cultural practices come under the scrutiny of cultural studies, including music, technology, literature and writing of all sorts, film and television, as well as concepts such as the nation and national identity, race and ethnicity, colonialism, gender, and sexuality. As art history broadens its scope, it increasingly overlaps with the work of cultural studies, and a number of art historians do work today that could be characterized as cultural studies.

Visual culture studies

Visual culture studies examines the social, political, and cultural significance of any human creation that is primarily meant to be experienced visually. This discipline emerged from the intersection of art history, cultural anthropology, archaeology, design history, and the sociology of art. It was strongly shaped, in particular, by the perspectives and theoretical innovations of cultural studies. Visual culture studies can as easily address hip-hop fashion as a Renaissance painting. It often focuses on the construction of social and political identities through the production and use of visual materials.

Connoisseurship

Connoisseurship is the practice of identifying, evaluating, and appreciating the quality of works of art. Practitioners of connoisseurship try to determine an artwork's culture, artist, and the time and place of creation in the absence of the artist's signature or supporting documentation. There is some overlap with both art history and art criticism—art historians, for example, seek to identify works, while art critics seek to evaluate their quality. Modern techniques of connoisseurship were developed in the nineteenth century, as practitioners such as

Giovanni Morelli (1816–1891) tried to systematize the process of attributing anonymous works of historical art to particular artists. Techniques of connoisseurship are rarely taught in undergraduate programs today, but they can be part of the training of museum curators, who often need to work with artworks that are not well documented.

Art history's toolbox: formal and contextual analysis

When starting out in art history, you may find it helpful to group the different approaches to interpreting works of art under two broad categories: "formal analysis" and "contextual analysis." These approaches are dependent on each other, and it's hard to separate them out completely. Often, art-historical interpretation requires us to do both at the same time.

Formal analysis includes those methods and questions that mostly concern the visual and physical aspects of a work of art. In formal analysis, you seek the answers to your questions in the work of art itself, usually without referring extensively to outside sources. You're exploring the visual effect of the work of art, looking at what the artist is trying to accomplish through visual means. In contrast, contextual analysis often requires you to go outside the work of art for your answers. What you're trying to do in contextual analysis is understand how a work of art expresses or shapes the experiences, ideas, and values of the individuals and groups that make, use, view, or own it. To develop a contextual analysis, you might look at such evidence as documents, other images, books from the period, the artist's writings, and histories.

Although these terms may be unfamiliar, you already practice the basics of formal and contextual analysis—for example, when you take the time to look closely at an advertisement. Responding to an advertisement engages many of the same processes as art-history analysis. You interpret a visual image (and often an accompanying text) to decipher its message and evaluate this message in context. The context is usually a targeted consumer group,

Reading captions for information

Artist's name

A caption usually gives you the artist's name first. If the artist's (or architect's) name isn't known, then it may say something like "artist unknown" or simply list nothing at all. An expression like "After Polykleitos" means that the work was executed by an unknown artist as a copy of an original by a known artist, in this case, Polykleitos. An expression like "in the manner/style of Rembrandt" indicates an unknown artist working in the style of a known artist. Similarly, "Circle of Rembrandt" or "School of Rembrandt" indicates an unknown artist who is thought to have worked closely with, or been a student of, a known artist.

Title

The title of the work usually follows the artist's name. Sometimes the title is one given to the work by an artist, as in Judy Chicago's *The Dinner Party*. Sometimes the title is a descriptive one, like *Portrait of a Lady*, that the artist didn't give to the work but that others have come to use as a convenience. The practice of giving titles to works of art hasn't been used in all time periods and cultures, so many works are named in this way. Sometimes the title of a work can refer to the patron or collector—for example, Velásquez's *Venus and Cupid* is also known as *The Rokeby Venus* after a famous collector who once owned this painting. Titles may also refer to the place where the work was found, like the *Venus de Milo*, or *Aphrodite of Melos*, which is named for the island where this marble sculpture was excavated.

Date

Sometimes the date for a work is precise, as when it's signed and dated by the artist.

Other times it is an approximate date determined by scholars. In this case, a range may be given (for example, "460–450 BC" or "9th–10th century AD") or the word "*circa*" may be used (*circa* is often abbreviated as "*c.*"). BC means "before Christ" and is equivalent to BCE, "before the common era." AD means *anno domini* ("in the year of our Lord," or after the birth of Christ). It is equivalent to CE, or "common era."

Medium

A caption will usually also list the materials used in the work because photographs often don't give a full or accurate impression of materials.

Size

The measurements are important because they give you a sense of the work's scale. Size and scale are often hard to judge from photographs, especially in a textbook, which can picture a miniature portrait and a palace on the same page.

Period or culture

This tells you the work's original time period or culture (as in Edo Period, Japan). In art-history textbooks where the chapters are organized by period or culture, this reference may be omitted from the caption. Sometimes a caption includes more specific information about the date, such as a particular dynasty for Egyptian art.

Collection and location

This information tells you where the work is now. For a building, it is usually the name of a city or geographical location. For artworks like sculptures, paintings, and textiles, it is often the name and location of a museum or private collection.

people who exhibit certain desirable characteristics. The ad is trying to persuade these consumers to purchase a product or, in the case of public service announcements, to inform them of something or persuade them to act in a particular way.

Let's take an example from a National Institute on Drug Abuse magazine ad campaign, which combines text and images to counter steroid use among high school athletes (Figure 1.3). Looking at the ad's formal qualities, you note that the word "steroids" appears in large, bold type in the upper left corner of the ad; it attracts attention, yet is immediately undermined by the question mark that follows it. The message would shift dramatically if, say, the word "steroids" were followed by an exclamation point. The message is underscored by the image of the athlete, whose appearance is clearly calculated to appeal to teenage readers. Note that he is very good-looking, with strong features and sexy, tousled hair, and is the same age as the target audience. He is pictured twice: in a closeup that lets the viewer see how good-looking he is, and also in action, lifting a large dumbbell, which suggests that he is a strong, successful athlete, even though he doesn't have the oversized muscles of someone on steroids.

The ad's visual message is enhanced by knowledge of its context. It targets high school athletes, and the text lists as the negative side effects of steroids: acne, baldness, stunted growth, and risk of HIV. Three of these focus on physical appearance, about which high school students typically have a lot of anxiety. The list does not include some of the more serious long-term effects of steroid use, including liver tumors, heart attacks, strokes, and kidney failure, perhaps because these might seem too abstract or remote to young people, who often see themselves as invincible or immune to death. The brief, punchy text is written as if spoken by the teenage athlete depicted and not the National Institute on Drug Abuse. In other words, this isn't the preachy argument of some government bureaucrat, but the direct statement of an equal.

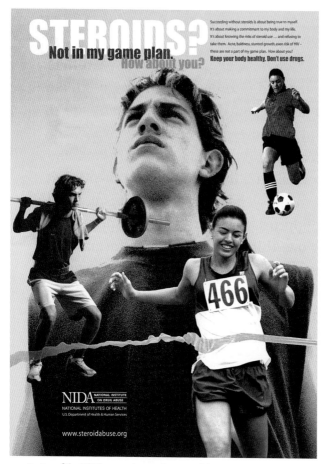

1.3 Poster of the NIDA campaign against steroid use, 2005

In the first paragraph, I analyzed the visual elements, focusing on design and the interaction of image and text to decipher the ad's message. In the second paragraph, I pursued a contextual analysis, relying on outside knowledge to try to understand the ad. You can take any advertisement and interpret its visual and contextual elements in a similar way. When you're browsing through a magazine, although you may not stop to work systematically through the process of visual and contextual analysis, your process of interpretation is related in many ways to art-historical methods.

Conclusion

I hope this chapter has provided you with a better understanding of what art history is and how it differs from other academic disciplines. As the great athlete Yogi Berra put it, "If you don't know where you're going, you'll end up somewhere else." As you advance in the study of art history, in addition to formal and contextual analysis, you'll learn to use theoretical models, such as psychoanalysis, feminism, and semiotics, that approach interpretation in specialized ways. But for now, thinking in terms of formal and contextual analysis may help you ask a full range of questions when you're interpreting works of art. The next two chapters will examine these fundamental methods of art history in more depth.

Chapter 2
Formal analysis

Looking isn't as easy as it looks
Ad Reinhardt (1913–1967), artist

In our culture, we are so constantly bombarded by visual images in television, movies, billboards, books, and magazines, that it's easy to develop habits of lazy looking. We're often on such visual overload that we don't take the time to examine images carefully and analyze what we're seeing. This chapter explains the basic art-historical method of formal analysis, which will help you to look carefully and frame good questions as you interpret works of art.

Formal analysis

Formal analysis doesn't mean simply describing what you see in a work of art, although description is part of it. It means looking at the work of art to try to understand what the artist wants to convey visually. In a sense, there's no such thing as pure formal analysis, totally divorced from contextual analysis. This is because you, the viewer, do provide a kind of context. The way that you interpret things is based on who you are—a person living in your place and time, with your education and experiences— and that inevitably shapes your interpretation. There are certain basic characteristics of works of art that you will focus on in formal analysis, such as color, line, space and mass, and scale. Often, these visual or physical qualities

of the work are most effectively discussed in terms of a sliding scale between pairs of opposite qualities, such as linearity vs. painterliness, flatness vs. three-dimensionality, or dark vs. light. You can find brief definitions of a range of specialized terms used in describing art in the Glossary on pages 164–165.

When you're engaged in formal analysis, remember that works of art change with the passage of time. Be sure that you're not ascribing visual or physical characteristics to the work that it didn't have at the time it was made. For example, although we now see the Parthenon as an austere, white marble structure, it was originally decorated with red, blue, and yellow paint, and polished bronze disks. The bright colors revealed when the Sistine Chapel ceiling frescoes were cleaned in the 1980s have radically altered our understanding of Michelangelo's work. A wooden mask from New Guinea may have originally borne decorations made of shells, feathers, leaves, or pigments. When you're not sure about changes over time in the work of art, you may want to consult outside sources rather than working purely from your visual experience.

Formal elements

Color

The first, basic step to undertake in analyzing color is to identify the different hues (red, blue, green, etc.) that an artist uses and see whether she is using a particular range of colors (e.g. primary colors, secondary colors) (Figure 2.1). You would also look at the characteristics of each color used. If it appears to be a representation of the color in its most vivid form, as it is represented on the color chart, it is highly saturated. If the hue can hardly be distinguished, then it is of low saturation. Value is a term that describes the relative lightness of a color—whether it tends more toward white or more toward black.

Line

Although the concept of line may seem to belong most obviously to painting and graphic arts, it's also a useful

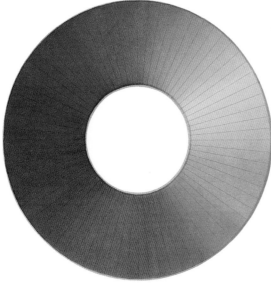

2.1 The Color Wheel

This color wheel by Eugène Chevreul divides the three primary colors—red, yellow, and blue—into 72 parts to show how these colors meld to produce the secondary mixtures of orange, green, and violet.

term in thinking about three-dimensional media such as sculpture and architecture. In discussing two-dimensional media, art historians often talk about linearity vs. painterliness, distinguishing between works that emphasize line and linear contours as compared with those that emphasize the play of light and dark. You might ask whether the line is strong and continuous, or broken up into many small hatches or pieces. For a building or sculpture, ask whether there is a strong sense of silhouette (the outline of the exterior contours) or whether the outline is broken up so that the viewer has little sense of it.

Space and mass

The term "space" indicates whether an image conveys a sense of three-dimensional space. The term "mass" describes the space created by an artwork, indicating whether the artwork conveys a sense of substantial form —as if it had weight or volume. These are actual characteristics of sculpture, architecture, and installations, but projected or illusory characteristics of two-dimensional media such as painting, drawing, printmaking, and

photography. The use of linear perspective or atmospheric perspective, for example, can establish a sense of spatial recession in a painting.

Scale

As part of a formal analysis, you'll want to consider scale, or relative size, both within the work and in relation to the viewer. Determine if there's a consistent scale used within the work, or whether different scales are used to emphasize or deemphasize certain elements in the image. Figures of gods, for example, are sometimes represented larger than other figures to indicate their divinity. Consider whether the image is monumental, life-size, or miniature in relation to the viewer.

Composition

The term composition is used to describe how an artist puts together all the above elements in the work of art. In a formal analysis, you will ask how these elements—line, color, space and mass, scale—contribute to the work's overall composition and its visual effect.

Initially, you'll be trying to answer some basic questions:

▸ What does the artist emphasize visually? What first attracts the viewer's attention?

▸ How does the artist emphasize this feature/these features visually? Through scale, line, color, etc?

▸ Is there an underlying rhythm, pattern, or geometric structure to the composition?

▸ Does the composition seem unified; that is, do the elements appear integrated or separate and distinct from each other?

▸ How can the emotion or idea evoked by this piece be described? How is this achieved visually?

▸ What is the viewer's position in relation to the work? Is the composition large- or small-scale? Is it horizontal or vertical in orientation? How do these characteristics alter the viewer's perception of the work?

▸ Is the work figurative or abstract?

Expanding on these basic questions about composition, I'll provide some specific questions you might ask in analyzing works of art in different media.

Two-dimensional art: painting, graphic arts, photography

A number of questions address the specific qualities of two-dimensional works—that is, works characterized by length and height, such as a painting, but of little depth (or three-dimensional form).

▶ How is color used? Are colors saturated? Where are the brightest colors? The darkest colors? Is there a wide range of colors or a narrow range of colors? Do the colors contrast or blend? Do the colors create a sense of calm or a sense of drama and excitement? Are they used to emphasize certain forms or elements in the work?

▶ Can you see the marks of the tools—pencil, brush, burin? Does the work seem highly finished or rough and unfinished? How do these qualities contribute to the overall effect of the work?

▶ Is there a strong contrast between areas of light and dark? Does this help to create the illusion of three-dimensional forms existing in space, or do the elements of the painting remain flat, emphasizing the picture plane?

▶ Does the artist try to create an illusion of depth, or does he or she use techniques to make the viewer aware of the picture plane?

▶ How are forms defined—through line or shading?

▶ Is there a sense of texture or a smooth surface?

Let's explore some of these issues of color, surface, and composition in *Marilyn (Vanitas)* by Audrey Flack (b. 1931) (Figure 2.2). Flack used a mechanical airbrush, rather than a conventional bristle brush, to achieve remarkably intense colors and a smooth surface. She employed the full spectrum of primary and secondary colors: yellow, orange, red, green, blue, and purple. Highly saturated colors predominate, although several hues are represented in multiple shades. The saturated red of the cloth in the foreground, for example, is set off

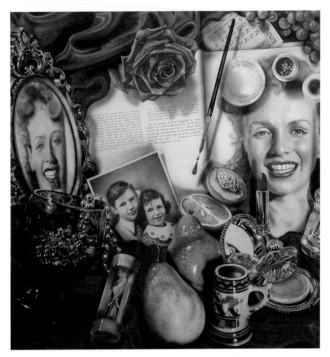

2.2 Audrey Flack, *Marilyn (Vanitas)*, 1977. Oil over acrylic on canvas. University of Arizona Museum of Art, Tucson.

A formal analysis wouldn't address the many provocative contextual questions raised by this image. In the tradition of European vanitas imagery, several elements in the painting refer to the passage of time (watch, calendar, hourglass, candle). The mirror, jewelry, and cosmetics allude to the particular ways that women fight the passage of time.

by the different shades and hues of pink in the hourglass, rose, and makeup. There is little sense of depth, for the elements of the composition crowd up against the picture plane. Despite this, the elements are not flat; instead, they appear as fully modeled, three-dimensional forms, as if they might pop out of the picture plane. The smoothness of the airbrushed surface enhances these illusionistic effects.

Although this image first strikes the viewer as a random profusion of brightly colored objects, in fact the composition is tightly constructed in three bands. An array of objects is set against a red cloth in the foreground. The middle register is occupied by the black-

and-white pages of an open book and three sepia-toned photographs, their starkness relieved by the touches of color provided by a pink rose and pots of cosmetics. The upper register is occupied by the more muted presence of a purple cloth, green grapes, and buff-colored calendar, which frame and set off the objects below. The large size of the image, 8 feet (2.4 metres) square, means that this array of intensely colored, three-dimensional forms almost overwhelms the viewer. The composition creates an image that is rich and lustrous, yet at the same time somewhat threatening.

Now let's explore some of the distinctive compositional effects achieved in printmaking. In *The Sleep of Reason Produces Monsters*, Francisco de Goya (1746–1828) used two techniques, etching and aquatint, to achieve both linear and tonal effects (Figure 2.3). The aquatint process, in which powdered resin is sprinkled on the plate before it is placed in an acid bath, produces grainy areas of tone. The etching process, in which the entire plate is coated with resin, and lines are drawn in the resin with needles, produces lines of various width. Goya used

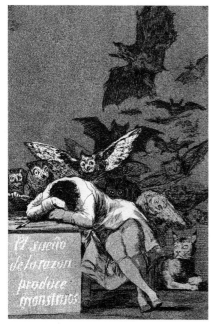

2.3 Francisco de Goya, *The Sleep of Reason Produces Monsters*, no. 43 from *Los Caprichos*, 1796–8. Etching and aquatint. The Hispanic Society of America, New York.

Wölfflin and formal analysis

In *Principles of Art History* (1915), the Swiss art historian Heinrich Wölfflin (1864–1945) made a major contribution to systematizing formal analysis through his definition of paired, contrasting terms to describe works of art and to distinguish their stylistic aspects. He defined five basic pairs of characteristics, which he saw as characterizing the Renaissance in contrast to the Baroque: linear/painterly, plane/recession, closed form/open form, multiplicity/unity, absolute clarity/relative clarity.

Wölfflin used the term *linear* to indicate works that emphasize outlines and that have a special kind of clarity in the spatial separation and relation of objects. *Painterly* form is more elusive—attention is withdrawn from the edges, outlines are de-emphasized, and form is developed primarily through the use of light and shade. Compare Käthe Kollwitz's (1867–1945) self-portrait, with its strongly delineated forms, and Rembrandt's (1606– 1669), in which few individual lines stand out against the areas of light and shade used to build the figure (Figures 2.4, 2.5).

Wölfflin's second pair is *planar vs. recession*. In a planar composition, as in a Classical relief sculpture, objects are represented parallel to the picture plane. The spatial recession is clear, achieved by a series of planes that are all parallel to the picture plane, as in much fifteenth-century Italian art. In contrast, a work characterized by recession is one in which the planes are not clearly articulated as separate parallel units. Spatial depth is created along diagonals, and the frontal plane is not emphasized. The compositions of Japanese screen paintings are sometimes organized in this way.

Closed vs. open forms is Wölfflin's third major distinction. In a closed form, the depicted contents seem to stand in clear relation to the edge of the image, so that the viewer can establish her position in relation to the image via its edge and has a clear sense of her relationship to it. In an open form, there's no such clear spatial relationship either within the work or between the viewer and the work. The elements within the image are not oriented in relation to its edge or surface. The Palazzo Medici-Riccardi by Michelozzo de Bartolommeo (1396–1472) and Frank Lloyd Wright's Robie House are a good illustration of closed and open forms respectively (Figures 2.6, 2.7).

Multiplicity vs. unity contrasts works in which the individual parts appear as independent units (even though they are subordinate to a whole), with works that are perceived as a whole, in which the individual elements of the composition do not stand out. Again compare the Palazzo Medici-Riccardi with the Robie House: the clear articulation of the stories and windows of the former contrasts with the latter's effect of a single horizontal, flowing shape, in which the different stories—even the interior and exterior spaces—are not easily distinguished.

Wölfflin's final pair, *absolute vs. relative clarity*, is closely related to the preceding pair. Absolute clarity refers to works with explicit and clearly articulated forms, and relative clarity refers to works with less explicit and less clearly articulated forms.

Although art historians today don't necessarily use these paired terms precisely, Wölfflin's comparative method still provides a useful model.

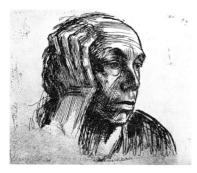

2.4 Käthe Kollwitz, *Self-Portrait*, 1921. Etching. National Museum of Women in the Arts.

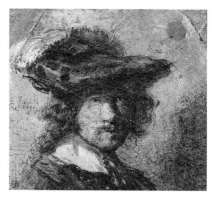

2.5 Rembrandt, *Self-portrait*, 1630. Pen and red chalk, bistre, wash. Musée du Louvre, Paris.

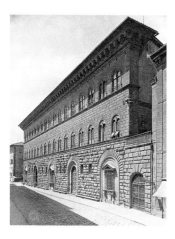

2.6 Michelozzo de Bartolommeo, Palazzo Medici-Riccardi, begun 1444. Florence.

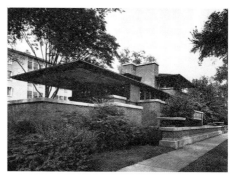

2.7 Frank Lloyd Wright, Robie House, 1907–09. Chicago.

these techniques to produce a visually dramatic and unsettling image full of contrasts of light and shade, tone and line. The aquatint background suggests a murky atmosphere. Bats—rendered with dense, inky black lines—emerge from the gloom. The sleeping figure slumps over his desk. His back and shoulders, delineated with nervous etched lines, seem to be bathed in a glaring light, created by leaving these areas of paper unprinted.

Sculpture

Sculpture can be either freestanding or relief, which means projecting from a surface like a wall or stone slab. There are a number of processes for making sculpture, including additive processes, in which the sculpture is built up, or modeled, from material like clay; subtractive processes, like carving stone or wood, in which material is taken away to create an image; and casting, in which molten metal is poured into a mold.

The following basic questions will help you address three-dimensional forms:

▸ What is the viewpoint suggested by the work? Does the sculpture visually lead the viewer to move around it and view it from different angles, or does it seem to guide the viewer to one position?

▸ What materials are used? How do they contribute to the work's form? Do the materials make open spaces within the sculpture possible, or do they require a more block-like form?

▸ Does the sculpture emphasize a sense of volume, of three-dimensional form, or of flatness?

▸ Does the sculpture use the play of light over the surface to create a pattern of lights and shadows? Does this emphasize the three-dimensional form or flatness? Does it create a sense of drama or movement?

▸ If the surface of the sculpture is colored, how does that affect the viewer's perception of the work? Does color serve to emphasize certain features of the work? Does it make the work seem more or less three-dimensional?

▸ What is the texture of the surface? Is it smooth or rough, dull or shiny?

Let's compare two sculptures (Figures 2.8, 2.9) to explore some of these issues. One is an Aztec stone figure depicting the goddess Coatlique, the other a bronze figure depicting Apollo by the Renaissance artist Giovanni da Bologna (1529–1608). Although both portray anthropomorphic figures of gods, they do so in very different ways. (Note that this analysis uses a basic piece of contextual information, the identification of each figure, as a starting point for a more insightful formal interpretation.)

Coatlique is a massive stone sculpture with a frontal orientation, showing bilateral symmetry along a vertical axis. The frontality demands that the viewer stand before the sculpture rather than walk around it or see it from multiple angles. The supernatural nature of Coatlique, the earth goddess, is indicated by the composition of the body. The head is formed of two rattlesnake heads, and the feet have feline claws. She wears a pendant in the form of a human head strung on a necklace of hands and hearts, and a skirt of entwined snakes, further emphasizing her divinity and striking fear in the viewer.

2.8 The mother goddess, Coatlique. Aztec, 15th century. Stone. Museo Nacional de Antropología, Mexico City.

In contrast, the figure of Apollo appears godlike through the perfection of his human form. The graceful, rhythmic positioning of the Apollo's limbs, turn of the head, and twist of the torso lead the viewer's eye around the figure. While the statue of Coatlique is solid and block-like, with few freely carved parts, the Apollo incorporates space within the figure, and the limbs are all separately articulated. The figure of the Apollo contrasts smooth stretches of flesh, characterized by a lustrous

2.9 Giovanni da Bologna, Apollo, 1573–5. Bronze. Palazzo Vecchio, Florence.

A mechanical device turned the Apollo in its niche so viewers could see it from every angle.

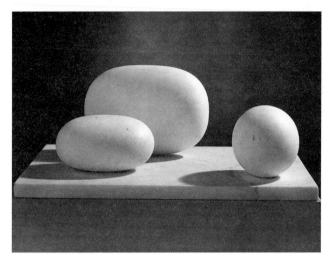

2.10 Barbara Hepworth, *Three Forms*, 1935. Marble. Tate Gallery, London.

bronze surface, with intricately detailed and textured areas, such as the hair, the robe draped over the lyre, and the lyre itself. He appears supernaturally elegant, graceful, and energetic.

Students beginning art history often find abstract art very challenging to interpret, so I'll briefly discuss an abstract work, *Three Forms* by Barbara Hepworth (1903–1975) of 1935 (Figure 2.10). Abstraction can occur in different art forms, so there's no particular significance to discussing it under sculpture rather than two-dimensional art. In abstract art the image does not directly represent observed reality. Abstract forms can be either purely geometric and non-figurative, or a reduction of observed forms into fundamental patterns or shapes. Hepworth's sculpture, for example, incorporates three marble elements of different shapes and sizes. One is spherical and spatially separate from the other two, which are oriented horizontally and rather elongated. These three elements can be seen as perfectly non-representational, a subtle meditation on the interrelation of geometric forms in space. At the same time, they can be interpreted as a distilled landscape, or even a figure (the sphere) in a landscape. Abstraction often exists on a continuum—that is, artworks are often neither

completely abstract nor completely figurative. So, when analyzing abstract works, take the time you need to see their more subtle aspects.

Architecture

Architecture demands that the viewer take into account both the physical and visual experience of the building and the spaces it creates. In discussing architecture, you may want to talk about the plan (or layout) of a building; an elevation (the side of a building); or the section (an imaginary vertical slice through the building). The following questions will be useful.

▶ What is the scale of the building in relation to humans?

▶ What parts of the building seem to be emphasized? Is the system of design readily apparent? Does the building appear to be composed of geometric or more organic (soft and curving) forms?

▶ Does the building seem accessible to the viewer from the outside? How large and visible are doors and windows?

▶ Does the building convey a sense of solidity or of the interplay of solids and negative spaces? Do the forms of the building use light and shadow to break up the sense of solidity? Is there a play of light and dark across the surface?

▶ How are ornaments used on the building? Do the ornaments enhance the viewer's awareness of three-dimensional form, or do they emphasize the building's surface?

▶ How does the building fit its environment? Does it seem to be distinct from or part of its surroundings? How does it change the viewer's perception of those surroundings?

▶ Is the interior divided into rooms or is it one open space? How does the arrangement of interior spaces either help to move the viewer through the building, or hinder the viewer's movement through the building? Which spaces are readily accessible and which are remote or blocked off?

▶ Is there a range of large and small spaces within the building? More or less elaborate spaces? Which spaces are most accessible?

Frank Lloyd Wright's Robie House provides an opportunity to consider some of these questions (see

Figure 2.7). The house observes few of the standard conventions of Western architecture. It sits low and seems to hug the earth, an effect enhanced by the strong horizontal lines created by the stone and brick façade. The house does not provide easy access to the viewer— it's hard to see where the entrance is, and exterior and interior spaces seem to flow together. Even the different stories of the house flow together and are hard to distinguish from each other. The overhanging roof lines, and the use of recessed windows, light stonework, and dark brick create a pattern of light and dark elements across the façade, further undermining the viewer's sense of solid form.

Installation art

Installation art is artwork made for a specific site that creates a total environment rather than simply being placed in a preexisting environment. The kinds of formal questions you might ask about an installation focus on the visual and spatial elements of the work and the viewer's experience of it. The issues are similar to those confronted in sculpture and architecture.

▸ What sense of space is created by the installation? How does the artist work with the environment or surroundings? Is it an installation the viewer can enter and interact with, or does the viewer stay outside the space?

▸ What effect does the environment created by the installation have on the viewer? Does it come across as overwhelming—does it dwarf the viewer—or make the viewer feel large? How does the scale of the elements work?

▸ How do light, color, and texture affect this sense of space and the viewer's experience of the environment?

▸ Does the installation change over time (perhaps through the participation of viewers, or through the decay of materials it incorporates)?

Let's take as an example the installation *Electronic Superhighway: Continental U.S., Alaska, Hawaii* by video and installation artist Nam June Paik (b. 1931) (Figure 2.11). Paik created this site-specific installation for the Holly

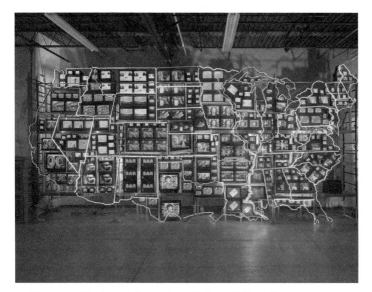

2.11 Nam June Paik, *Electronic Superhighway: Continental U.S., Alaska, Hawaii*, 1995. 49-channel closed circuit video installation, neon, steel and electronic components, approx. 15 × 40 × 4 ft. Smithsonian American Art Museum, Washington, D.C. Gift of the artist 2002.23.

Solomon Gallery in New York City. It included a brightly colored neon map of the continental United States superimposed over a bank of video monitors (Alaska and Hawaii appear on side walls). The monitors within the border of each state played images reflecting culture, history, and contemporary life in that state. The one exception was New York State, whose monitors displayed live video images of the gallery visitors. This not only made them part of the artwork, challenging their passive status as viewers, but also made them conscious of their role as part of culture, history, and contemporary life. The neon map, which outlines states in different colors, called to mind the clear, colorful maps of school books, but the scale of the piece was monumental—potentially overwhelming the viewer with the visual intensity of its neon lights and multiple, flashing screens.

Performance art

In performance art, the artist—or, more precisely, the artist's movements, gestures, and sounds, either alone or

in dialogue with an audience—becomes the artwork. Although performance art is an integral part of the contemporary art scene, artists in the early twentieth century also engaged in it. Questions about performance could include:

- Does the performance piece seem improvisational, or planned and rehearsed?

- How does the artist interact with the audience? Does the audience remain relatively uninvolved, or does the audience participate in the performance? Is the audience's reaction or participation guided by the artist, or is it an uncontrolled aspect of the performance?

- Is the space important to the performance? Has the artist altered the performance space in any way?

- How are words, music, and gestures used?

- What is the presentation of the artist's body? What clothing and/or accessories does he or she wear?

Such questions are also relevant to the analysis of many other artworks, from an Italian church altarpiece to an African mask.

In 1992, the artists, scholars and activists Coco Fusco (b. 1960) and Guillermo Gómez-Peña (b. 1955) collaborated on a performance piece to critique the quincentennial celebration of Columbus's arrival in the Caribbean (Figure 2.12). They pretended to be the representatives of a recently discovered native people put on display in various museums, as native peoples were often displayed in the past. They created a set for the performance, a cage that they furnished carefully with both "indigenous" artifacts and desirable "modern" trade goods, such as a transistor radio. The artists dressed in "indigenous" clothing made of skins, fiber, bones, and feathers. They interacted with viewers—speaking a nonsense language, posing for photographs, touching their hair or clothing—but the interaction was not scripted, and was usually initiated by the viewers. In these ways, Fusco and Gómez-Peña simultaneously played to, and challenged, viewers' dehumanizing stereotypes about native peoples.

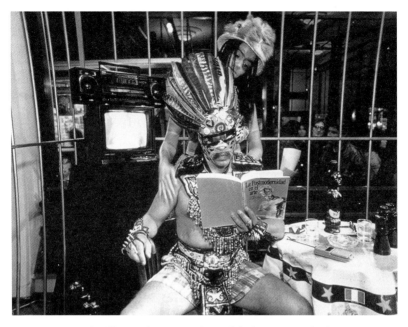

2.12 Coco Fusco and Guillermo Gómez-Peña, *The Couple in the Cage: A Guatinaui Odyssey*, 1992.

Although this performance piece challenges the idea that museums offer universal cultural truths, to the artists' surprise many viewers took it at face value. Not seeing the irony or the social and historic commentary threaded through the performance, these viewers responded to the cultural authority of the museum and expected the exhibition to present them with the "truth." While some viewers reacted with outrage at what they perceived as a human rights violation, others were pleased to have an opportunity to interact with genuine natives. When viewers realized that these natives weren't "real," they were variously angry, puzzled, or embarrassed.

Digital art

The term "digital art" applies to works of art made with digital computer technology. This may include websites, CD-ROM, and virtual reality as well as the incorporation of digital processes into established media, such as photo retouching, graphic design, video editing, and architectural rendering, in which the final outcome may take a more traditional form. Digital artworks are often works that it would not have been possible to create using more traditional media. In addition to questions you might ask based on those for other art forms, questions specific to digital art include:

▶ What role does digital technology play in the creation of this work? What effects does it make possible that would not have been possible otherwise?

▶ Do these effects heighten the sense of reality or of fantasy in the work? That is, do they make the image seem more or less "real"?

▶ How does the digital technology invite the viewer to participate in the piece?

In 2003 Marie Sester created ACCESS, an installation work that used digital technology to raise the viewer's awareness of surveillance and detection (Figure 2.13). In ACCESS, web users could track individuals in public spaces using a robotic spotlight and an acoustic beam system. The persons tracked did not know who was doing the tracking or why, nor did they realize that the acoustic beam projected audio that only they could hear. At the same time, the web user did not know that his or her actions triggered sound toward the target. Thus, both the tracker and the tracked were engaged in a paradoxical communication loop, simultaneously connected and yet disconnected. In an age where surveillance technologies

2.13 Marie Sester, ACCESS, Ars Electronica, 2003.

are increasingly part of everyday life, ACCESS worked to denaturalize them and make them obvious. The spotlight could be associated with the glamour of celebrity—a Broadway show, for example—or with more sinister police or military surveillance.

Textile and decorative arts

Textiles, ceramics, and utilitarian or decorative objects of all kinds can be analyzed in formal terms, just like painting, architecture, and sculpture:

▸ Is the function of the object immediately evident? How is the object designed to be functional? Are there aspects of the design that could hinder its functionality?

▸ How are materials used? Is there an emphasis on richness or variety of materials?

▸ Is there an emphasis on texture? How would this object feel to the touch?

▸ Is there an emphasis on simplicity or complexity of form and design? Are there figural and/or geometric elements on the surface? Do the decorative elements, if any, make reference to the function of the piece?

▸ What is the role of color or line in shaping the viewer's perception of the work?

▸ For textiles specifically, what techniques have been used to create the cloth (for example felting, weaving, plaiting, quilting, or appliqué)? Is it a close weave or an open weave? Is the design simple or intricate? What yarns are used (for example cotton, linen, sheep's wool, llama wool)? Does the textile incorporate other materials, such as glass or wood beads, or sequins?

A Chinese Ming-period porcelain flask will give us a chance to explore some of these issues (Figure 2.14). The figure of the dragon appears dramatically in reserve— that is, in an unpainted area framed by the painted blue background. The body of the dragon wraps around the flask, emphasizing its elegant curve. The decoration on the neck shifts to a floral motif, distinguishing the different parts of the vessel. The painting technique shifts there, too; the flowers are not left in reserve, like

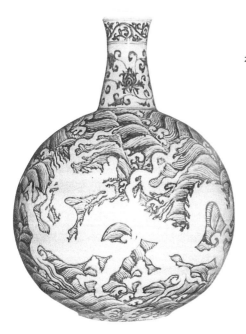

2.14 Flask, c. 1425–35. Porcelain, decorated in blue underglaze. Ming dynasty. Palace Museum, Beijing.

An important contextual issue to raise in discussing this flask would be the significance of the dragon motif. In China, dragons have long been associated with powerful forces of nature such as wind, thunder, and lightning. During the Han Dynasty, China's emperors adopted the dragon as an imperial symbol.

the dragon, but are directly painted in blue on the surface. Although the shape is functional, the vessel is made of fine porcelain with an intricate design, and was probably decorative rather than actually used to contain drinks of any kind.

Conclusion

Careful looking is one of the two basic tools of art history. The guidelines provided in this chapter will help you examine works of art in a systematic and thorough way, through the process of formal analysis. The next chapter will help you with that other basic tool of art history, contextual analysis.

Chapter 3
Contextual analysis

Always design a thing by considering it
in its next larger context—a chair in a room, a room in a house,
a house in an environment, an environment in a city plan.

Eliel Saarinen (1873–1950)

When you undertake a contextual analysis, you're trying to understand the work of art in a particular cultural moment. As the quote by the architect Eliel Saarinen above suggests, a focus on context gradually enlarges our view and expands what our scholarship (or, in his case, design) should encompass. This can mean focusing on the work of art as it exists today, or on the work of art in its own time or at another point in history. It can also mean looking at the social, political, spiritual, and/or economic significance of the work.

Art and context

People often talk about art "in context," but that isn't a very satisfactory approach in some ways. It suggests that context (culture) is already all set without the work of art, as if the work of art has no effect on individuals or society. Of course, if it were true that visual images don't have any effect on people, then there wouldn't be any advertising on TV or in magazines!

To think of a work of art "as" social context rather than "in" social context means recognizing it as something that has an effect on people, on how they think and feel and act, and on larger social processes—how groups

of people think and feel and act. Works of art and social context are often thought of as mutually constituting, that is, having an effect on each other. Works of art are shaped by historical processes, which are in turn shaped by works of art in a continual interaction.

Contextual questions

The following are some basic questions to ask in developing a contextual analysis. Not every question is applicable to every artwork. For example, if you don't know the artist's identity, for whatever reason, then there are a number of questions that you can't ask about the creation of the work.

One range of questions focuses on the people involved in the creation, use, and viewing of the artwork—the patron, artist, and viewers:

▶ Who were the patron, artist, viewers?

▶ What sorts of records did the artist leave about the creation of this work? Did the artist say anything about his or her intentions in creating the work? Were other artists or workshop assistants involved?

▶ What were the patron's motives in sponsoring this work? To what extent did the patron participate in its creation? What does the contract for the work or correspondence about it reveal? Was the patron acting individually, or on behalf of an institution?

▶ Who was able to see the work? Under what circumstances? What was the response of contemporary viewers to this work?

Other questions for building a contextual analysis address the physical work of art, its location, and use:

▶ When was this work made?

▶ Where was it originally located?

▶ In what rituals was this work used or seen?

▶ Does the work make use of rare and costly materials? Does it include materials that have ritual or symbolic value? Are they new or innovative in some way?

▶ Are the artist's techniques new or innovative in some way? Was there any significance to the choice of techniques?

Still other contextually oriented questions address the larger social issues presented by the work of art:

- ▸ What was the political, religious, or social context in which this work was created?

- ▸ What is the subject? Why would the artist, patron, or viewer be interested in a depiction of this subject?

- ▸ Was this a new or innovative subject, or a new treatment of a familiar subject? If so, what prompted the change? If not, what was the motivation for conservatism?

- ▸ What political, religious, and/or social messages are being conveyed through the subject matter or artistic style of this work?

- ▸ Was this a new or innovative artistic style? If so, what prompted the change?

Let's see how some of these questions might be used to begin interpreting a work of art, taking as an example the Selimiye Mosque built in Edirne, Turkey, in 1567–74 (Figure 3.1). The architect was a man named Koca Mimar Sinan (1489–1588), and in a contextual analysis you will want to find out as much background about him as

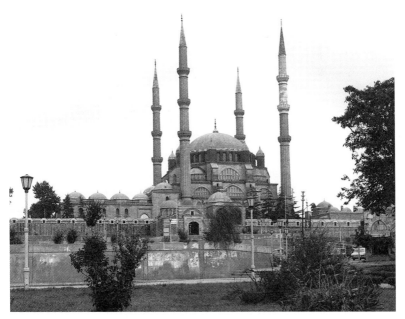

3.1 Koca Mimar Sinan, Selimiye Mosque, 1567–74. Edirne, Turkey.

possible. Sinan was, in fact, an amazingly productive architect who designed more than eighty large Friday mosques. He actually began his career as a soldier and engineer, and was not appointed architect to Sultan Suleyman the Magnificent (ruled 1520–1566) until 1538. His patron for the Selimiye Mosque, the person who commissioned and paid for its construction, was Suleyman's son, Selim II (ruled 1566–1574). In this case, you would want to examine Selim's reign, his patronage of mosques generally, and of Sinan's work in particular. In terms of viewers, you would want to think about not only the Muslim residents of the city and those who worshipped at the mosque, but also foreign visitors and what their impressions might have been.

The second set of questions listed above raises some other interesting issues. The Selimiye Mosque is located in Edirne, which was the first Ottoman capital in Europe. You would want to consider the role of this provincial capital city in the Ottoman empire at this time. Since this is a mosque built for Friday worship, you might want to look at the floor plan of the mosque and see how it is constructed to accommodate the large numbers of people who would assemble there on Fridays.

As far as the third set of contextual questions is concerned, there are numerous political and religious messages conveyed by the building. In designing this building, Sinan wanted to build a dome to surpass that of Istanbul's congregational mosque, which was originally built as the Christian church of Hagia Sophia (Holy Wisdom). You might think about the message conveyed by such an act, in surpassing a dome constructed in the sixth century by Christians, and its construction in an Ottoman capital city so close to the main centers of western Europe. In this regard, you might want to think about Selim's motives as patron and Sinan's motives as architect. You would consider the range of activities that went on at this site, and the complex of buildings that form part of the mosque, including a *madrasa* set aside for study, a hospital and charity kitchens, a covered market and public baths.

The minarets provide an opportunity to see how the formal questions can lead to contextual insights and vice versa. In a formal analysis, you would discuss the remarkable soaring presence of the minarets. They spring up from the mass of lower buildings of the mosque complex and frame the dome itself, accentuating its own lightness and upward thrust. You would note that, since the mosque is located on a foundation at the city's edge, the minarets dominate the skyline and provide a landmark visible from many parts of the city. You would discuss the remarkable engineering required to build these soaring minarets, each of which is more than 295 feet (89.9 metres) high but only 12 feet (3.81 metres) in diameter at the base. This might lead you into a contextual discussion of Sinan's engineering accomplishments and the practice of engineering generally in Ottoman culture. From a contextual standpoint, you would also focus on the fact that only royal mosques were permitted to have more than one minaret and usually no more than two, so that the presence of four in this building is extraordinary. You might think about why Sinan and his patron Selim might want to construct a mosque with four minarets in this particular city at this particular time—the complex of artistic and political factors that might have prompted such a decision.

Art out of context? Museums and art history

Museums are a fact of American cultural life today. Most Americans have made at least one visit to a museum, and these institutions can seem as natural a part of the cultural landscape as churches or town halls. But museums haven't always been around (neither have churches and town halls, for that matter). Museums are, in fact, cultural institutions with a specific history that are dedicated to specific ideals and goals. It's important to be aware of this, because the museum is the place where you will most often study art, even though a lot of art wasn't actually made to be exhibited there. The museum itself may shape the viewer's understanding of a work of art, by displaying it in a different context than it

may have had in its original cultural setting. At the same time, museums have their own cultural agendas, histories, and politics that must be taken into account in any experience of art you have in a museum.

A brief history of museums

For the Greeks, a *mouseion* was a place not for the display of art but for contemplation, a philosophical institution dedicated to the Muses. The Romans followed the Greeks in making "museums" places of philosophical discussion. Even if museums then weren't quite what they are today, traditions of collecting and display were part of many ancient Mediterranean cultures. Egyptian pharaohs collected natural-history specimens and works of art. In both Greece and Rome wealthy citizens often maintained private art collections, and temple treasuries were open to visitors.

Later, the treasuries of the great medieval cathedrals presented splendid displays of gold and silver artworks that attracted pilgrims and other visitors. During the Renaissance, many nobles and wealthy merchants formed collections of rare and wondrous objects, both natural and made by humans, and displayed them in "cabinets of curiosities." Collecting art—painting, sculpture, prints, drawings—became an accepted activity of the elite. It was at this time that the word "museum" came into use again, but now it described a collection of natural objects or works of art that promoted comprehensive and encyclopedic knowledge, rather than philosophical contemplation.

In the eighteenth century, some individuals opened their collections to the public, and the modern museum was born. Many great museums today, such as the Louvre and the British Museum, trace their origins to this time. Through the nineteenth century, museums rapidly filled with the spoils of war, or artworks gathered by colonialists and missionaries. For better or worse, modern museums are wrapped up in the history of the nations that fostered their growth.

Are there counterparts to the museum in other non-

Western cultures? Although museums as we know them today have their roots in the European Enlightenment, traditions of collecting and display are widespread. The emperors of China collected works of art and displayed them in imperial academies and palaces. Islamic leaders also collected works of art that they displayed in palaces for the pleasure of the elite. Buddhist temples in Japan have amassed collections of calligraphy and other artworks for display on special occasions. Today, museums are found around the world. There are many different kinds of museums, dedicated to anthropology, history, natural history, science, technology, popular culture, among other things. What we might define as "art" can be found in any of these institutions.

Museums and the experience of art

The ways that museums can shape our understanding of works of art was something I realized most fully during a visit to Florence, Italy, as a student. I had just spent most of the day in the Uffizi Gallery, one of the world's great painting collections, where I wanted to study Italian altarpieces from the fourteenth and fifteenth centuries. Many of them were displayed together in attractive galleries with bright lights and white walls (Figure 3.2). When I left the museum, I stepped into a church not far away to see another altarpiece (Figure 3.3). As my eyes adjusted to the darkness, I glimpsed the painting, lit by the soft glow of candles and the diffused light entering through the stained glass windows. The air was faintly scented with incense, and murmured prayers rose around me. An elderly woman knelt before the altarpiece and prayed intensely.

What a different experience! It wasn't a question of better or worse, but of each place yielding very different insights. At the Uffizi, I was able to see a lot of altarpieces all together, so that I could compare different artistic styles and iconographies and observe the changes that took place in this artform across time and space. At the church, I was able to experience a single altarpiece in a way that, despite the passage of time, was close to the

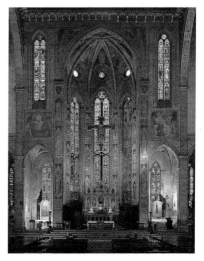

3.2 Photograph of gallery, Uffizi, Florence.

3.3 Photograph of church interior, Santa Croce, Florence.

conditions for which it had been created. The altarpiece was surrounded by a church's distinctive smells, sights, and sounds, with the low light muting yet enriching the colors of the painting.

I was lucky enough in Florence to experience similar works of art in the church and museum in close proximity, but that's not necessarily typical. As you visit museums to study works of art, you'll have to keep in mind the ways that the museum environment shapes your perception of the work. For example, think about the lighting level, your position in relation to the work, the number of people around you, the kinds of noises you hear, the way works of art are grouped. Compare this to the original context(s) in which the work would have been seen. At the same time, it's important to keep in mind that much European and American art from the late eighteenth century on has been made with public museums or gallery spaces in mind as places where the

artworks may appear. Much contemporary installation art or performance art, for example, needs the kind of large, public spaces that museums and galleries provide.

The process of interpretation: confronting your assumptions

When interpreting works of art, it's important to be aware of the assumptions you make. You must question those assumptions—ask where they come from, why you maintain them, and how they shape your interpretation. Some of these may be simple factual assumptions: you believe the Renaissance in Italy extended from the fifteenth to the sixteenth century. Others may be more interpretive biases or concepts: you believe Italian Renaissance painting is a naturalistic tradition of representation, or you believe that Italian Renaissance art represents humanity's highest achievement. Both of these kinds of assumptions, factual and interpretive, should be questioned when you're undertaking art-historical analysis. Instead of assuming that you know or understand a work of art you're studying, consciously take the position that you don't know anything for sure— everything you think you know must be tested and rethought. It's not that your assumptions are necessarily wrong, just that you need to be aware of what they are.

The challenges of cross-cultural interpretation

> Everything I need to know about Africa is in those objects.
> Pablo Picasso (1881–1973)

Like many modern artists, Picasso was interested in and inspired by the art of other cultures. He kept masks and figural sculptures from Africa and the Pacific in his studio and made many visits to ethnography museums. Unlike art historians today, Picasso was primarily interested in the formal qualities of these works, rather than their cultural context. His statement above suggests that he didn't need to study cultural context to under-stand a work: for him, understanding arose from a visual engagement with the piece. Let's put Picasso's assertion

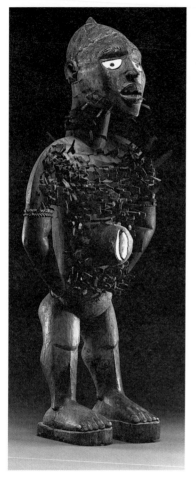

3.4 Power figure (*nkisi nkonde*), 19th century. Wood and other materials. Kongo people, Democratic Republic of the Congo. The Field Museum, Chicago.

to the test with the sculpture pictured in Figure 3.4. Think about how you might interpret this work, without researching any contextual information about it. What does the artist seem to emphasize? What ideas or emotions does the work provoke in you, the viewer? Can you tell how the work was used originally? Why are nails and metal blades inserted in the surface?

Here's a brief interpretation of sculpture of this kind, one that draws on both formal analysis and contextual analysis for its insights. As you read it, think about how much of this insight is available to the viewer simply through looking:

In the late nineteenth and early twentieth centuries, Kongo peoples, who live along the Atlantic coast of central Africa, used such sculptures in rituals that dealt with social and personal problems, including public strife, theft, disease, seduction, and the accumulation of wealth. The figure contains relics of the dead person, whose spirit was a powerful force to be harnessed toward the desired end. A ritual specialist, *nganga*, owned the figure and used it as a medium to access the spirits on behalf of his or her client. The insertion of nails and blades into the surface of the sculpture was not the work of the artist, but of subsequent users of the piece. Hammering a nail or blade into the figure attracted the attention of the spirit associated with it and roused that spirit to action.

The figure itself is impressive, it conveys a sense of strength and power in its large, staring eyes and muscular arms held at the ready. However, to the people who made and used it, the wooden sculpture itself was not the most important part of the piece—the medicines and relics were. In fact, *nganga* specialists often simply kept the medicines and relics in simple clay pots, and they were considered just as effective in that form.

Now, although Picasso asserted that he was not interested in context, in some ways he—like us—couldn't help but interpret works by applying his own cultural criteria to what he was seeing. His looking process wasn't neutral. Even if he wasn't explicitly interested in context, in some sense he was creating a context or meaning for the work because of the ideas and assumptions he couldn't help but bring to bear. For example, Picasso would probably have found wooden figures of this kind more interesting and more important for the qualities of their carving than for the small bits of bone and herbs contained in them—a perception exactly opposite to that of the Kongo people themselves.

Even more revealing, Picasso, like many other people at the time, called works like this "fetishes." For him this might have seemed to be simply a descriptive term, but we can see it today as loaded with cultural assumptions. In Picasso's time, the word "fetish" indicated a material object worshipped by people who endowed it with divine

powers and the ability to act like a person to fulfill their wishes. At the same time, the term fetish was also being used in psychoanalysis to indicate an irrational sexual fixation on an object (as in a "foot fetish"). The two meanings of fetish imply that the religious practices connected to these figures were at the very least misguided, if not "sick." Rather than taking these practices at face value within their own cultural context, the term fetish assigns these figures a negative value based on European cultural values and practices.

So even Picasso, who explicitly denied an interest in context or the interpretation of context, was looking and interpreting with culturally informed eyes. Picasso wasn't "wrong" to do this, because it's really unavoidable. We all come to art history, to the process of interpretation, equipped with prior knowledge and our own cultural experiences. We're not blank pages, and this is not a bad thing. Some of your assumptions and prior knowledge will increase your understanding and your ability to interpret the work and to engage with it on a variety of levels. The point is that you should try not to apply what you know from your own culture unthinkingly to the interpretation of works from other cultures. It can be misleading to assume that there are universal values expressed through art or universal forms of representation. Too often these kinds of "universal truths" turn out to be just your own specific cultural beliefs or values in disguise.

Now think again about your initial interpretation of the Kongo figure. How many of your own cultural truths do you find in it?

The challenges of historical interpretation

The past is a foreign country: they do things differently there.

L.P. Hartley (1895–1972), The Go-Between

What do these words, a famous line from an English novel, have to do with art history? They remind us that we cannot assume that we understand the past, or that there is an immediate connection or understanding between us

Is African art anonymous?

If you look at the captions for African art in your textbook, you will often see, instead of the artist's name, a statement like "artist unknown" or "anonymous." This reflects the history of collecting African art and Western attitudes toward Africa, more than African cultural practices. But it's easy to overlook this history and simply assume that the individual artist is not important in many African cultures.

Historically, artists in many African cultures— sculptors, weavers, metalworkers, potters— were often celebrated individuals, widely known in their communities and beyond for their skill. But because in most African cultures history was an oral tradition, the name of the artist was passed on verbally and not written down.

In the late nineteenth and early twentieth centuries, the outsiders who collected in Africa—explorers, colonists, soldiers, missionaries, and anthropologists—often didn't record the names of the people who made or owned artworks. These collectors frequently assembled objects to illustrate a timeless picture of a culture, not to document individuals and their work. They usually didn't value these objects as "art," so it wouldn't have occurred to ask for the name of the "artist." Moreover, objects were often collected in such large numbers that it was difficult to record a lot of information. For several decades, art historians and anthropologists have worked to rediscover the names and histories of African artists.

The stool illustrated here is one of about twenty objects that art historians think were made by artists living in or near a village called Buli in southeastern Democratic Republic of the Congo (Figure 3.5). Since the individual artist's name isn't known, it is usually attributed to "the Buli School." This attribution copies the accepted way of naming anonymous Western artists or groups of artists according to their location, distinctive styles, or signature pieces.

3.5 Buli School, Stool, late 19th century. Wood. Hemba people, Democratic Republic of the Congo. British Museum, London.

One scholar has suggested that an artist named Ngongo ya Chintu carved this stool and a similar example in the Metropolitan Museum of Art, New York. Objects in this style were used throughout the Hemba region, further complicating their attribution to particular artists.

and the past, even within our own culture. In this sense, studying a work of art from the past is like visiting a foreign country. As an art historian, you must learn to "speak" the language of that past culture and learn to "practice" its customs. Once again, the challenge lies in not making easy assumptions about what you know, or think you know, or can ever know, about the meaning of a work of art.

An easy linguistic example of this principle of interpretation is the word "artificial." Today it usually means "fake" or "not natural," as in "artificial flavoring and coloring" listed on food labels. The word often carries a negative connotation. But in the eighteenth century, artificial meant simply "made by human hands." For example, on his voyages of Pacific exploration, Captain James Cook (1728–1779) collected both "artificial curiosities" (baskets, sculptures, textiles) and "natural curiosities" (shells and plants). To complicate matters further, we can also note that earlier, in the sixteenth century, "artificial" actually had a positive connotation, as in "made with art," or "full of deep skill and artistry." So even a common word like "artificial" requires that you be sensitive to when and where and how and why it is used—in other words, you have to be sensitive to the particular context in which you find it.

Similarly, visual images have the same kind of changing meanings through time. There are original meanings—created by the artist, patron, and viewers— and then there are the meanings that subsequent generations create and find in the work. You, as an art historian, must be aware of this process, and aware of how differently you might look at a work compared with its creator, patron, initial audience, or people of other times and places. You may regard a painting like *Olympia* by Edouard Manet (1832–1883) as completely unobjectionable, but remember that many nineteenth-century viewers were shocked and dismayed by Manet's depiction of a naked young girl staring out directly at the viewer.

The Wedding Portrait, or *Arnolfini Wedding*, by Jan van Eyck (c.1390–1441), which dates to 1434 (Figure 3.6),

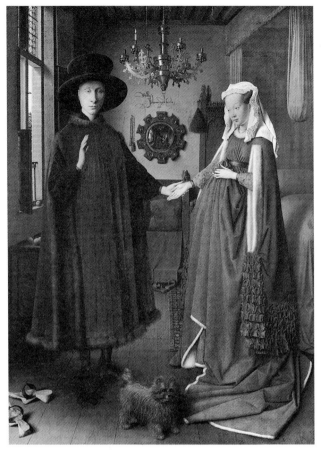

3.6 Jan van Eyck, *Arnolfini Wedding*, 1434. Oil on panel. National Gallery, London.

provides a good example of the challenges of historical interpretation—in fact, the work has become famous for its resistance to easy interpretation. Once again, think about how you might interpret this work without looking up any contextual information about fifteenth-century Europe, van Eyck, or the Arnolfini family.

First, we should note that there's some question as to whether this painting does depict a wedding ceremony, as its commonly used titles suggest. It may actually commemorate another legal arrangement between the couple, such as the husband granting power of attorney to the wife. If the painting does indeed represent a wedding, you may be wondering when the bride and

groom are going to go off and get changed for the ceremony. In fact, the white wedding dress and the morning coat are nineteenth-century inventions, and there was no standard wedding costume at this time. If this image does depict a wedding, did these two get married in their bedroom? What about the church or the court house? Again, at the time, it wouldn't have been at all surprising for the ceremony to take place in a private home. Weddings were primarily contractual agreements, and a religious ceremony was not considered essential.

You probably also suspect that the artist is making a statement about the wealth and status of these people. The couple's fur-trimmed clothing is something that, both then and now, indicates wealth. But take the oranges on the chest at left, behind the man. You probably didn't think twice about them—nothing remarkable, right? Grocery stores practically give them away in season. But to a northern European at the time, oranges were "the fruit of kings," a rare and costly import from Spain. Fifteenth-century viewers would have interpreted the inclusion of these oranges—so carelessly and luxuriously scattered over chest and windowsill—as a sign of great wealth, in the same way that you might react to bottles of the finest champagnes in a portrait today.

But this painting isn't just a straightforward "snapshot" recording an event; it's also a highly complex and subtle statement about the couple. Many aspects of this painting are still poorly understood, and the precise nature of the overall meaning isn't entirely clear. Scholars have described this work as a large puzzle, for each element seems to contribute to this larger meaning. The painting seems to address marriage and family, domestic life and the responsibilities and duties it brings to each member of the couple. The little dog, for example, is on one level a sign of wealth, for it is a rare breed. Yet the dog also symbolized fidelity, especially marital fidelity, at this time. Notice that the woman stands in the part of the room dominated by the bed, perhaps a symbol of domesticity, while the man stands next to a window,

which opens to the outer world. The woman pulls up her gown over her stomach, creating a rounded silhouette that evokes pregnancy, and therefore the perpetuation of the family lineage.

The continuing mystery of this famous painting reminds us of the limits of interpretation and historical understanding. The kinds of documents that might answer our question directly (a description of the painting by the artist or patron, a contract for it, the impressions of early viewers) don't survive. Does this mean we shouldn't or can't interpret the work? I think it means that interpretation is more necessary than ever if we are going to engage with the work on levels beyond simply admiring Van Eyck's technical skill as a painter. To achieve understanding, viewers today must work both from the painting itself, for it provides its own primary evidence for interpretation, and also from general knowledge of northern Renaissance culture and society.

Let's go back to the quotation that begins this section. It makes a simple but profound point: be aware that historical works, even if from your own culture or the recent past, are in some sense foreign and not necessarily easily comprehensible. At the same time, you don't need to feel entirely cut off from the past, for the past is only knowable in the present, and is, in that sense, part of the present.

Art and its controversies

When thinking about art in context, it's important to remember that art is not always produced in an atmosphere of complete and happy agreement among patrons, artists, and viewers. Often there is a range of different and sometimes conflicting intentions, responses, and interpretations at play. As noted above, responses to art change with time, too: what was once shocking may become acceptable and vice versa. Many different cultures and time periods have seen conflict over art—what it depicts, how it depicts it, where and how it is displayed, how people respond.

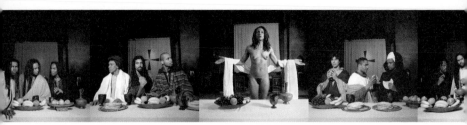

3.7 Renee Cox, *Yo Mama's Last Supper*, 1996. Cibachrome print, 2 ft 6 in × 12 ft 6 in (76.2 × 381 cm).

Over the past twenty years, for example, with the ascendancy of conservative politicians in the United States, controversies involving public funding and questions of "decency" have attracted widespread public attention. Perhaps the most famous of these concerned the 1990 retrospective exhibition of photographs by Robert Mapplethorpe (1946–1989). The exhibition, which included homoerotic and sadomasochistic images, came under attack for its content, especially since it had received funding from the National Endowment for the Arts (NEA). In response, Congress cut funding to the NEA and required the organization to keep in mind "general standards of decency and respect for the diverse beliefs and values of the American public."

More recently, in 1996, artist Renee Cox (b. 1957) offended some viewers with her nude self-portrait as Christ in *Yo Mama's Last Supper* (Figure 3.7), an image modeled on Leonardo da Vinci's (1452–1519) *Last Supper*. Cox, born in Jamaica and raised as a Roman Catholic, intended the image as an exploration of the idea that all humans are created in God's image—even someone as marginalized in American culture as a Black woman. Among Cox's most vocal critics was the mayor of New York Rudolph Giuliani, who called the work anti-Catholic and obscene, and threatened to form a "decency commission" to monitor the Brooklyn Museum, where the work was displayed. The case became a lightning rod for discussions of First Amendment Rights and public funding for the arts. Of course, such controversies are not new. Like Cox, Michelangelo was severely criticized for depicting a nude Christ in his Sistine Chapel *Last*

Judgement (1536–41). Although his patron, Pope Paul III (reigned 1534–49), was greatly moved by the work, later popes, from as early as 1546 and into the eighteenth century, ordered loincloths to be painted over the nude figures whose genitals were most prominent.

Contextual interpretations should take into account the varied positions of the artwork's different constituencies. The artist's and patron's intentions may be quite far apart, as may be the response of different viewers to the work. A good example is the controversy over the destruction of the monumental stone Buddhas at Bamiyan, Afghanistan (Figure 3.8), early in 2001 on the orders of the ruling Taliban faction. Carved into the living rock, the Buddhas had presided over the trade route known as the Silk Road since the third century AD. It is possible that their destruction was not simply an inevitable outgrowth of a generic "Muslim" aversion to figurative imagery. After all, local Muslim populations had coexisted with the Buddhas for centuries. Moreover, a delegation from the fifty-five-nation Organization of

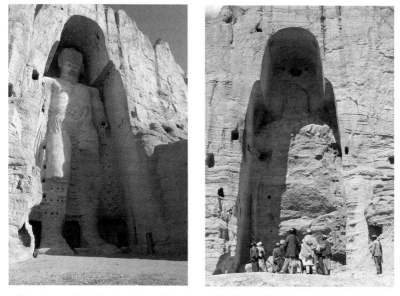

3.8 Rock-carved Buddha, Bamiyan, Afghanistan. *Left:* the Buddha c.1997, before it was demolished. *Right:* the Buddha after it was demolished by explosive charges in 2001.

Islamic Conference petitioned the Taliban not to destroy the images, and local Taliban members would not do it.

The destruction of the statues can be seen in the context of contemporary politics, at a time when the repressive Taliban regime was rejecting the international power structure that was pressuring it in various ways. The Taliban's horrific action can be interpreted as rejecting the international cultural values that also encourage the preservation of historical artifacts like the Buddha images. These kinds of complexities are at the heart of nuanced contextual analysis.

Style and meaning

> 6 months after Mary Alice went to git Sofia out of prison, she begin to sing. First she sing Shug's songs, then she begin to make up songs her own self. She got the kind of voice you never think of trying to sing a song. It little, it high, it sort of meowing. But Mary Agnes don't care. Pretty soon, us git used to it. Then us like it a whole lot.
>
> Alice Walker (b. 1944), The Color Purple

Celie, the character speaking here in Alice Walker's novel *The Color Purple*, is talking about her friend Mary Alice's artistic style as a singer. Celie talks about the songs Mary Alice sings, which she first borrows from another singer then makes up herself. She then describes Mary Alice's voice style, the way she puts a song across. Little, high, meowing—it may not be pretty, but it's all her own. That voice style, combined with Mary Alice's choice of song, goes a long way toward defining her artistic style as a singer. (Of course, Alice Walker has her own writing style at work here—she uses dialect and first-person narrative to reveal Celie's inner world.)

The concept of artistic style is an important one in art history. You could say that style is where art's formal and contextual aspects meet. Art historians have spent a lot of time trying to define artistic style and explain how and why it changes over time and varies between individuals and groups. Ernst Gombrich (1909–2001) defined style with deceptive simplicity as "any distinctive . . . way in which an act is performed." In a famous essay, Meyer

Schapiro (1904–1996) defined artistic style as "constant form—and sometimes the constant elements, qualities, and expressions—in the art of an individual or a group." Style is sometimes identified in terms of a time period or culture (Italian Renaissance; Edo period, Japan); in terms of a group of artists (Rembrandtesque or School of Rembrandt); or in terms of an individual artist's style.

Style is important to art historians because, if works of art both reflect and shape the world around them, then style is one way that they do that. That is, style communicates religious, social, political, and moral values through the formal properties of the work of art. The idea that style both expresses and shapes values or ideas may seem difficult to grasp, but let's look at it another way. Take the concept of lifestyle, for example. The word "lifestyle" indicates a certain set of behaviors, consumer products, and ways of living chosen by an individual, usually to express a sense of connection to a certain group or idea. Lifestyle choices are affected by gender, race, class, ethnicity, age, sexual orientation, personal taste—and they affect the way we experience these characteristics. An individual's choice of a car, for example, often has as much to do with image as it does with functionality. The popularity of SUVs (sports utility vehicles) in the United States at the turn of the twenty-first century is a good example—people who drove nowhere more exciting than the local grocery store wanted these rugged, off-road vehicles in order to appear outdoorsy and adventurous.

The complex interplay of an artwork's features is important in defining a style, not any one feature in particular. Subject matter is a good example of this. Images of the Buddha have been made in widely varying cultures and time periods, and in many different formal styles. Considered alone, the subject matter of the Buddha does not tell you where and when a particular image was made. To find this out, you would have to look at other evidence, including the style in which the figure of the Buddha is depicted. Similarly, particular formal features are not necessarily diagnostic of a cultural style.

Doric columns, for example, originated in ancient Greek architecture, but this type of column was later used in different styles of Roman, Italian Renaissance, and nineteenth-century Western architecture.

Conclusion

For me, the process of interpreting a work of art from another culture or from the past is like speaking a foreign language. I may not speak a language well, and may not fully understand what native speakers are saying, but a great deal of successful communication is still possible, despite my imperfect grammar and vocabulary. So, too, with a work of art. You may not grasp all of its meaning—if that's even possible, given the variable understandings and interpretations of the very people who made and used the work—but there is much that you can know and understand. Your tools are contextual and formal analysis.

Chapter 4
Writing art-history papers

Begin at the beginning and go on till you come to the end; then stop.

Lewis Carroll (1832–1898), Alice in Wonderland

Combining the challenges of writing with an unfamiliar subject, like art history for the beginning student, makes for stress. When you set out to write a paper, you can't go wrong following Lewis Carroll's advice, but I'll try to provide more extensive guidelines here to help you along in the process. Most of this chapter is devoted specifically to art-history papers; I provide only basic information about how to deal with references, endnotes and bibliographies, and how to quote and paraphrase. If you need more help with research and writing, consult one of the more general writing guides listed in the bibliography.

Structuring art-historical arguments: interpretation vs. opinion

One of the objections I hear a lot from students who are unhappy with their paper grades is "But art history is just a matter of opinion. Mine is as good as yours!" As I hope you've come to realize by now, art history isn't opinion, it's interpretation, which might be better characterized as supported and informed opinion. That is, in doing art history you have to be able to deal with the available evidence in a way that meets not only your instructor's expectations, but also the standards of the discipline.

It's sometimes difficult to make this shift with art history, as opposed to other subjects such as chemistry or physics, because visual images are such a big part of our lives. You already deal with visual images in a variety of ways and in a variety of contexts. You may be used to going to museums and looking at art, and having all sorts of opinions about it, in a way that you don't generally do in a chemistry lab. The kinds of opinions you express on these occasions may be a fine way to talk about art with a friend, but in the context of an art history class, where you are a scholar working with the discipline's established methods of inquiry, these ideas are not necessarily convincing.

Here's an extreme example. You may decide that space aliens built the Parthenon. That's all very well, when you're standing on the Acropolis and explaining this version of history to a (very tolerant) friend. However, that version of events won't be convincing in an art-history class, because you wouldn't be able to support it according to the standards of the discipline. To do that, you would first have to provide some evidence of space aliens at work on the building (of course, if you're a true space-alien enthusiast, that may not prove to be so difficult after all . . .). You would also have to explain away all sorts of other evidence that contradicts what you're saying, such as ancient texts that describe the work of the architects Iktinos and Kallikrates (both active c. 447–c. 432 BCE) at the site. The idea that space aliens built the Parthenon may be valid as a personal opinion, but it's not valid as an art-historical interpretation.

Just think what the response would be if students took an "it's my opinion so it's OK" approach to chemistry class. In a chemistry lab, if your test tube at the end of an experiment didn't contain 2.5 ml of blue liquid, you wouldn't say to the instructor, "Well, it's your opinion that this experiment ought to yield 2.5 ml of blue liquid. I'm very happy with 1.2 ml of green liquid. And so what that I didn't add ammonium hydroxide? I just didn't feel like my test tube needed it—it wasn't the focus of my

experiment." Because it's easier to recognize chemistry as a discipline that is separate from other areas of knowledge and experience, students are less likely to take the "it's my opinion so it's OK" attitude there than in art history. But both chemistry and art history have their established methods as academic disciplines, and when taking classes in these subjects, you should follow them. The idea is that you'll become a more rigorous, flexible, and creative thinker through your engagement with these established methods.

In art history, we're not looking for a result as specific as 2.5 ml of blue liquid. Your professor is generally not looking for just one interpretation, but for a careful process of interpretation. Yet even as there's typically no one right answer, some interpretations will be more convincing than others, because they take into account more of the available information about a particular subject.

I sometimes use the analogy of being a lawyer to explain this process of building interpretations rather than opinions. In a courtroom trial, you and the opposing lawyer have the same set of information, but you interpret it in different ways—you argue for two different stories from this same set of information. Moreover, the story you create has to be presented in a certain way, according to the court's standards for the kind of evidence and presentation of evidence that are permissible in a trial. Bottom line, your story has to convince the jury and the judge by accounting for all the evidence available. If you contend, in a murder case, that your client is innocent, but you can't satisfactorily explain why his fingerprints were all over the gun used in the crime, then your interpretation is not going to convince anyone.

Formal-analysis papers

Formal-analysis papers help you develop the ability to examine works in a sustained and analytical way. This is a fundamental process in art history, and so introductory art-history survey classes often help students develop these skills through paper assignments. As the last two chapters emphasized, you have to be able to do formal

analysis well in order to be able to do contextual analysis well and, ultimately, to work in a more precise and sophisticated way with various theoretical perspectives. Keep in mind that a formal-analysis paper is not a long, minute description of the artwork. Instead, you're trying to see how far you can interpret the image without consulting outside sources beyond minimal identification.

Taking notes

The challenge in preparing to write a formal analysis is making sure that you engage in a process of sustained looking. Our culture and education don't train us to do this, so it helps to have a systematic procedure. When you're standing in front of a work it's easy to think that you'll remember all the details of it when you get back to your desk. Unfortunately, that too rarely proves to be true, so you need to incorporate a dense note-taking practice into the process of looking. I'm assuming here that you've been assigned to write a formal analysis of a work that you can see in person.

I'll share my own working method here, but remember that you'll have to adapt it so that it works for you. The first thing I do is sit down in front of the piece and spend some time just looking at it, absorbing the different aspects of it without writing anything down. I try to pay attention to visual aspects of the piece that jump out at me immediately, as well as those that take time to engage my attention. If you're working with sculpture or an installation, it's essential to move around it and look at it from different angles.

After you've looked for a while (at the very least fifteen minutes), start taking notes about the piece. Write a detailed, systematic description of the work, noting its really striking features. When you've written down as much as you possibly can—this will easily take half an hour—go off and do something else. Get something to drink, look at some other works of art, browse the bookstore or another gallery if you're in a museum. Then go back to the work and look at it again, another fifteen minutes or so, without writing anything. Be aware

of features that emerge that you didn't see before. Then take a whole new set of notes. At this point, a set of issues, or themes, or a perspective should be shaping up. Go back over both sets of notes and see if you can clarify these ideas into a thesis statement, and then be sure you have all the visual evidence you need to support that thesis.

Finally, draw the work. Even if you've found a postcard of the work in the museum gift shop or a reproduction in a book, still draw it because it's a very effective way to engage your eye in careful looking. I do this when I'm researching: even if I take a dozen photographs of a piece I'm studying and write pages of formal analysis, I will draw it because that process enables me to see things I won't notice any other way. Don't get hung up on whether your drawing is "good" or not or whether you have any talent—this drawing is a working tool. The process may prompt other insights into the work, so be sure to write these down as well.

It's often really helpful to go back on another day and repeat the looking process—especially with a rough draft of your paper in hand. If reality intervenes and you just don't have time, then it's even more important to make sure that you take detailed notes and visually engage with the work in a serious way the first time you see it.

Structuring your paper

I'll take a fairly complex work as an example, a freestanding wooden sculpture made by an unknown Dogon artist in Mali (Figure 4.1). This is a challenging artwork to interpret formally because it is composed of two figures. The cross-cultural aspect of the analysis further complicates the process. When working cross-culturally, it's important to try to understand the larger cultural aspects underlying particular aspects of the image, and not label them as "expressive" or "naturalistic" in Western terms when they might not have been intended that way in their original context (see Chapter 3).

You can see how the temptation in writing a formal analysis of this work would be to start by describing one

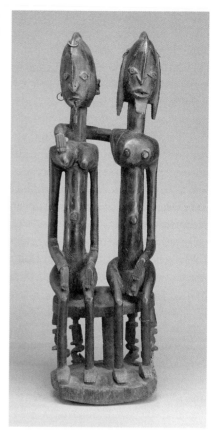

4.1 Seated Couple. Dogon, 19th century or earlier. Wood and metal, height 28¼ in (73 cm). The Metropolitan Museum of Art, New York.

figure completely and then proceeding to the other and describing it completely. But that's not a sufficiently interpretive perspective. Instead, the way to go about working with this object is to spend some time studying the two figures both separately and together. After all, there's a reason the artist carved two figures together in this particular way. If you take the time to look carefully, you may develop some insight into this image, even if you don't know all that much about Dogon culture.

During your study of the work, you would notice that the figures are male and female, and that the composition emphasizes their equality, harmony, and connectedness. The figures are the same size, and they are balanced—neither is larger, more impressive, or more powerful than the other. They sit in the same

position, and the male figure wraps an arm around the female figure to emphasize their connection. A series of elongated vertical elements—arms, legs, necks—underscores the similarity of the figures and leads the eye around the composition. At this point, some basic contextual information would help you develop your formal analysis; for example, knowing that figures like this appeared on altars and expressed the idea of balanced duality, a central tenet of Dogon religion.

Your formal analysis paper would be built on this formal understanding of the work rather than simply an exhaustive description of it. This understanding would form the thesis of your paper, and help you structure an opening paragraph something like this one:

> Are men from Mars and women from Venus? Is there really no possibility for the sexes to get along, work together, and understand each other? Although the Jerry Springer Show may leave viewers with this impression, the Metropolitan Museum's Dogon *Seated Couple* indicates otherwise. This depiction of a seated man and woman emphasizes balance, harmony, and equality. Every visual element of the work stresses these qualities—from the posture of the figures to their size to their complementary elements.

The writer then organized the body of the paper around each of the issues stated in this opening paragraph. Don't organize a formal analysis paper "geographically," as if moving inch by inch over the surface of the image—this may lead to a descriptive rather than interpretive approach.

The comparison paper

Formal-analysis assignments often ask students to write a paper comparing and contrasting two works of art. In such papers, you'll discuss the similarities and differences between the works, and use those similarities and differences to deepen your understanding of what's going on in each. The best way to write a comparative formal-analysis paper is not to write first all about one work and then all about the other, but to discuss them together. This means that your introductory paragraph

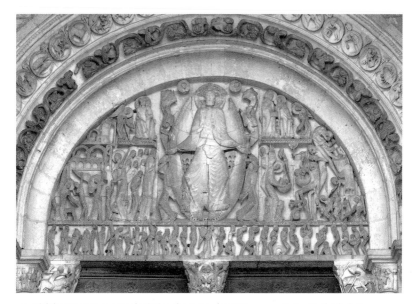

4.2 Gislebertus, tympanum depicting the *Last Judgement*, c. 1130. Autun Cathedral, France.
In this scene, angels escort the saved to Paradise, while demons torture the damned and carry them off to Hell.

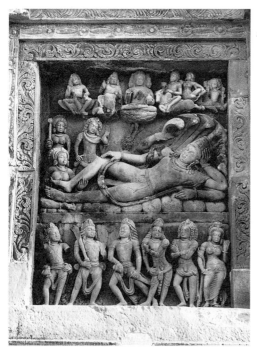

4.3 *Vishnu Narayana on the Cosmic Waters*, c. 530. Stone relief panel. Vishnu Temple, Deogarh, Uttar Pradesh, India.

presents a thesis about what the juxtaposition of the two works means; then each paragraph of the body takes up a different issue in turn.

Let's work with an example, the *Last Judgement* by the French sculptor Gislebertus (active first half of the twelfth century) from the Cathedral of Autun, France, and the Vishnu Narayana on the Cosmic Waters from the Vishnu Temple at Deogarh, India (Figures 4.2, 4.3). There are some basic similarities between these two images: both are relief sculptures that ornament sacred architecture, and both depict deities. There's also a fundamental difference between them, namely the religious contexts in which they were made, Christian and Hindu respectively. Use these basic characteristics as a springboard to start comparing and contrasting the images. You've seen the easy similarities and differences, so look for the ones that aren't so obvious. These should help you to come up with the issues you want to discuss in your paper. Here's a good introduction to this essay:

> Portraying the gods is an enduring concern in the visual arts associated with many religions. Images incite devotion, prayer, respect for religion, and perhaps even good behavior. Two relief panels, one depicting Christ at the Last Judgement and another depicting Vishnu on the Cosmic Waters, show both similarities and differences in how they depict divine beings. Both strive to create an image of the divine body that shows the deity as different from ordinary mortals and awe-inspiring. Both choose big, cosmic moments, the destruction of the universe in the Christian image and the creation of the universe in the Hindu image. And, finally, the architectural setting is key to understanding these images. Both come from sacred buildings and use clearly organized compositions to convey their messages to worshippers in this public setting.

Each one of the three main issues identified here is then discussed in the body of the essay—this introduction serves almost as an outline for the essay. The writer goes on to organize the paper around the three main issues—the divine body, the "big moment," and the architectural setting—rather than discussing first one

work then the other. With the latter form of organization, you risk an essay that's overly descriptive, rather than interpretive, and one that fails to fully compare and contrast the two images. This doesn't necessarily mean that you have to deal with each issue for both images in one paragraph—you'll probably have far too much to say about each to squeeze all that commentary into one paragraph. As an example, here's how the issue of the divine body is handled by this writer:

> Both images use relative scale to visually represent divinity. Christ and Vishnu appear larger than all the other figures in these images. The figure of Christ is a vertical axis at the center of the relief. His arms gesture expansively outward, dividing the souls of the saved and the damned, so that he takes up a maximum amount of space. He is exactly twice as large as the angels who help him in this work, and he is four times as large as the humans. Similarly, Vishnu is a horizontal axis, dividing the composition in half as he dreams the universe into being. He is so large that if he stretched out fully he would break through the frame. No other figure in the scene, even though they are all gods or spirits or demons, is even half as large as he is.
>
> Both of these artists also use anatomy, clothing, and jewelry to emphasize the figures' divinity. Vishnu has many arms, and wears an elaborately detailed crown and necklace to denote his special nature. Vishnu wears transparent clothing to show off the smooth perfection of his rounded limbs. Unlike four-armed Vishnu, Christ's body is a human body and he wears a simple, graceful robe. He is shown clothed and his anatomy is de-emphasized because for Christianity the emphasis is on the other-worldly aspects of the body. Only the damned, susceptible to the sins of the flesh, are depicted unclothed in this scene. However, Christ has a halo around his head and another kind of halo, a mandorla, around his body to show his divinity.

Notice that the writer here is using detailed observation, but including the telling details only. There's no point in describing each feature of the image minutely —and, in fact, a lot of your notes and descriptions from your initial study of the works may not make it into the final paper. Also note that the writer does use some basic

contextual information to shape this visual analysis. She identifies the figures as Christ and Vishnu, the religions as Christianity and Hinduism, and the scenes as the Last Judgement and Vishnu dreaming the world into being. But she focuses on what the image can tell us about Christ and Vishnu in formal terms, not what outside sources might reveal. For example, the writer does not turn to the biblical account of the Last Judgement to compare the visual depiction of this event with its textual inspiration.

Research papers

You may well be assigned a research paper as part of your introductory survey course. This is where you get to dig in as an art historian, combining formal and contextual analysis to engage deeply with art. There are several different kinds of paper assignments. You may write about a specific work of art, or a specific institution (for example, the history of a particular museum), or you may write about an art historian and his or her ideas. Writing a research paper exposes you to the literature of art history, including scholarly works written from strong points of view, with highly developed arguments. These kinds of works are different from the textbook that you use for class, which is necessarily wide-ranging and fairly neutral in its approach to images. While these new kinds of sources can be exciting and challenging to work with, they can also be hard to evaluate.

Developing a topic and starting your research

As an example, I'll walk through the steps of researching *Judith and Her Maidservant Slaying Holofernes* by Artemisia Gentileschi (1593–1652/3), painted around 1625, now in the Uffizi (Figure 4.4). In deciding on a paper topic, you may have chosen to work on this painting because of the unusual subject and the dramatic way Gentileschi presents it: a determined Judith cuts through Holofernes's neck with a powerful twist of the arm, while her maid coolly holds him down on the bed. You would know enough about Baroque art and women artists from class to think that:

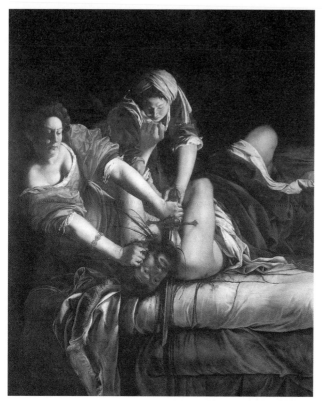

4.4 Artemisia Gentileschi, *Judith and Her Maidservant Slaying Holofernes*, c. 1625. Oil on canvas. Uffizi, Florence.

The story of Judith comes from the apocryphal Book of Judith. When the Assyrian general Holofernes laid siege to the Israelite town of Bethulia, the widow Judith set out with her maidservant to rescue her people. She went to Holofernes's camp and promised to help him, but then when he was drunk and asleep, she cut off his head. Judith and her maidservant escaped back to Bethulia, where she advised the people to display the head on the town walls. The Bethulians easily defeated the demoralized Assyrians, making Judith a heroine.

- ▸ there are relatively few women artists in this period, so Gentileschi is an unusual and potentially interesting character;

- ▸ the painting represents a powerful woman, so it might be interesting to look at how the artist's identity as a woman affected her choice and treatment of the subject;

- ▸ it might be interesting to compare this image to the

treatment of this subject by other artists in the period—male and female, if possible.

So that gives you an initial set of questions to pursue for the research. Notice that there's no developed thesis statement yet, just a set of ideas to pursue. The thesis will emerge from the process of research.

The first two things to do in pursuing this topic are to consult the bibliography of the textbook for the course and to do a keyword search for "Artemisia Gentileschi" in the library's online catalogue. You would come up with a rather long list of potentially relevant sources, from which you would choose to consult first a few of the most substantial, recent, and directly related sources that are most directly related to it:

Bissell, R. Ward. *Artemisia Gentileschi and the Authority of Art: Critical Reading and Catalogue Raisonné.* University Park: Pennsylvania State University Press, 1999.

Christiansen, Keith and Judith W. Mann, *Orazio and Artemisia Gentileschi.* New York: Metropolitan Museum of Art, 2001.

Garrard, Mary D. *Artemisia Gentileschi: The Image of the Female Hero in Italian Baroque Art.* Princeton: Princeton University Press, 1989.

Garrard, Mary D. *Artemisia Gentileschi around 1622: The Shaping and Reshaping of an Artistic Identity.* Berkeley: University of California Press, 2001.

Johnson, G.A., and Grieco, S. F. M., eds. *Picturing Women in Renaissance and Baroque Italy.* Cambridge: Cambridge University Press, 1997.

These are all books published by major university or museum presses that you would know are likely to present very good scholarship. Several of these sources are current, so they'll also indicate what you should read from the earlier literature, the classics that still have something to offer. This saves you from having to survey the entire earlier literature yourself.

In this search you would also note as interesting, and probably fun and provocative to read, a novel about

Artemisia Gentileschi:

> Lapierre, Alexandra. *Artemisia: A Novel*. Translated by Liz Heron, New York: Grove Press, 2000.

You would be less likely to consult this source first thing:

> Garrard, Mary D. *Artemisia Gentileschi*. New York: Rizzoli International Publications, 1993.

The catalogue entry goes on to describe this book as "IV. (unpaged): ill. (some col.); 36 cm." Given this description, and the publisher Rizzoli, which produces high-quality but not usually scholarly books, you would recognize this as a "coffee table" book. Because a good scholar wrote it, you would certainly put it on your list to consult at some point, but it wouldn't be a priority. You would expect that many of the insights Garrard presents in this kind of book would appear elsewhere in her more scholarly publications.

You would then consult an online index to periodic literature to check recent articles in journals. This one would be essential first reading:

> Spear, Richard E. "Artemisia Gentileschi: Ten Years of Fact and Fiction." *The Art Bulletin* 82/3 (September 2000): 568–79.

The abstract (a brief summary of the article) notes that it is a review of the scholarly literature, as well as literary and cinematic representations of Gentileschi and her work. Again, you would use this to orient yourself in the field, to try to understand better the major themes and trends in the scholarship on Artemisia Gentileschi. You would also note the following article:

> Cohen, Elizabeth S. "The Trials of Artemisia Gentileschi: A Rape as History." *The Sixteenth Century Journal* 31/1 (Spring 2000): 47–75.

Depending on the research angle you decided to pursue, this article might become highly relevant, but you would consult the more general resources first in developing a working thesis to guide your research. You would note that this article is part of a special issue of the journal

devoted to matters of gender, which may potentially help generate some interesting questions to frame a thesis. You would also note in the periodic literature a number of recent reviews of Bissell's work.

Now your task would be to read these sources to develop more specific ideas to pursue in research. You would make it a priority to read the chapter devoted to Gentileschi's depictions of the Judith theme in Garrard's earlier book, *Artemisia Gentileschi: The Image of the Female Hero in Italian Baroque Art*, as well as the introductory chapter, which provides an overview of the artist's career. When reading Spear's overview of the recent literature, you would pay attention to the themes and issues he identifies in the scholarship on Gentileschi, but would be careful at the same time to keep an open mind and develop your own viewpoints. In reading Bissell's work, you would note that he often provides an interesting counterpoint to Garrard's interpretations as well as a lot of background information on each of Gentileschi's known works. Christiansen and Mann's exhibition catalogue provides interesting analysis of Artemisia in relation to her father, the painter Orazio Gentileschi (1563–1639)—a perspective that may be relevant, depending on your thesis. A first read-through of Johnson and Grieco's book would reveal that it doesn't include an essay on Gentileschi per se, although there are scattered references to her work through the text. It includes some interesting analyses of gender and the representation of gender, so you would note the points that seem interesting and keep it in mind to go back to and read in depth if your research turned in that direction.

One of the things you would see through this reading process would be the prevalence of psychoanalytic interpretations of Gentileschi's work, especially in terms of the impact of her experience of having been raped as a young woman on the kinds of imagery she chose. Garrard and others argue that the depiction of Judith is a kind of rewriting of the rape—the heroic woman decapitates (and thus symbolically castrates) the brutal man who desires her. While this perspective on the imagery is

interesting, it has already been explored in great depth, and doesn't leave much room for you to say something new, to put together your own interpretation.

In this context, you might look at other aspects of this painting. The fact that it was originally purchased by Florence's powerful Medici family, for example, might lead you to explore aspects of patronage in Gentileschi's work. Who was buying all these images of strong, heroic women? What was Gentileschi's relationship to her patrons? Was it similar to or different from that of contemporary male artists? Thinking about it a bit more, you might well focus on the fact that she produced seven paintings for the Medici family, all depicting either single female figures or narratives in which women are the protagonists. Why were the Medici so interested in her work? Were they interested in this distinctive female imagery, or was there something else about the paintings that made them desirable? And if so, how did they come to terms with the female imagery and the gender of the artist? These very specific questions (compare them with the more open-ended questions that initiated the research process) constitute the project's working thesis.

This working thesis would require the research to go in three directions: further into Gentileschi's career and these seven paintings; into the Medici family and its patronage of Gentileschi and other artists; and into patterns of patronage in Baroque Italy. Bissell's work would be particularly helpful here: he published all the known paintings by Gentileschi and includes a great deal of information about her financial arrangements and her various professional relationships. Garrard's second book, *Artemisia Gentileschi around 1622: The Shaping and Reshaping of an Artistic Identity*, would also be key, as it focuses on two little-known paintings, the Seville *Mary Magdalene* and the Burghley House *Susanna and the Elders*, both executed circa 1621–22, just after she produced *Judith and Her Maidservant Slaying Holofernes*. Garrard's analysis of the ways that identity, gender, and market pressures shaped the artist's production of these two works may well provide some insights into her

relationship with her patrons around this time. Meanwhile, reading Christiansen and Mann's exhibition catalogue from this viewpoint would help place Artemisia Gentileschi's experiences as an artist in a larger context and help identify what she might have learned from her father about working with patrons or how his connections might have benefited her.

Keeping notes

You've probably already developed a method of note-taking that works for you, from high school or other college courses. I'll just review a few of the options briefly here.

A lot of students take notes on index cards. In this system, you keep one set of index cards 3 × 5 in (7.5 × 12.5 cm) with full bibliographic references. Then you take notes on another set of cards 4 × 6 in (10 × 15 cm), putting the author's last name and the title on the top line with a page number, then a subject line below, and then the notes or quotation below. This system is effective because you can shuffle the cards around, putting quotes together in different ways to help assemble your argument. I will admit that the index-card system does not work well for me, because I'm not a particularly organized person. I tend to lose the cards, they get jumbled up, and it's hard for me to get around seeing the notecards as an unrelated mass of quotes.

I prefer to take notes in a notebook, which gives me a better sense of the development of each author's argument. Having the notes on each work in succession in the notebook also helps me keep track of my research process. Plus, I have a very visual memory and so I often remember where quotes are situated on a notebook page when I need to look them up (a talent that doesn't work with index cards). However, for some people, this method buries the material—it's too hard to find things in the pages of a notebook.

Making notes directly on a computer, either via a word-processing program or a notecard program, can also be very effective. I actually prefer an old-fashioned

notebook to making notes directly on a computer because I'm more accurate writing by hand than typing. This is especially important when I'm dealing with archival materials or foreign-language sources, where it's critical to keep track of correct spelling. Programs such as Endnote help organize and follow bibliographic references. They can save you a lot of time, because once a work is entered, it never has to be typed out again—you can pull out the reference and paste it into a word-processing document in a variety of formats.

Remember to make photocopies of related works or works relevant to the argument that you find as you're researching. For example, if you're working on a painting, you may want to keep some photocopies of the drawings related to its development, depictions of the same subject by other artists, and different works done by the artist around the same time. If you're studying architecture, make photocopies of the whole building photographed from various angles, its ground plan, details, other buildings by the same architect, and build-ings constructed around the same time by other archi-tects. Even though these images may not be immediately relevant to your research, you may need them later on for

How many sources should I use?

There's no simple answer to this question, though students ask it all the time. Different topics will generate bibliographies of different lengths. For some areas, there are lots of sources; for others, few. Some approaches to a subject will require more sources than others. What this question really asks is, have I done enough research? The answer to that question, of course, lies in the quality of the paper you produce. With experience you'll learn when you've done enough research to develop a thoughtful and original inter-pretation of your subject.

Professors sometimes specify a minimum number of sources to help guide beginning researchers in their work. For example, when I ask students to prepare an annotated bibliography as part of the process of writing a ten- to twelve-page research paper, I specify that it should include ten really good, useful sources. The actual number of works cited in the final paper will vary, but I use this as a rough guide to make sure that students are digging into the literature.

comparative purposes as you build your interpretation. (Also, in practical terms, doing this as you go along means that you are more likely to have the illustrations ready for the final copy of your paper.)

That said, I'll also note that the worst thing you can do is overuse the photocopier. Just accumulating masses of photocopies of articles and book chapters won't help you develop a good argument. You don't process and synthesize information completely when you simply photocopy a text or go through it with a highlighter. (That's also why I recommend note-taking over highlighting for assigned readings; see Chapter 5.) In order to develop a convincing interpretation, you have to synthesize and evaluate the arguments of other authors, distilling useful information as you go along.

Resources for research

One of the most effective things you can do is consult the reference librarians who work at your college library, especially if there's one who specializes in art history. Reference librarians are trained to help you with your research—take advantage of this! All you have to do is bring an outline of your paper or the ideas you're working with, a list of the bibliographic references you already have, and ask for suggestions. I also strongly advise taking a tour of your university or college library and a class on its catalogues and other online resources. Libraries usually run them at the beginning of the year and sometimes periodically throughout the semester. This will help you to work easily and efficiently in the university's libraries. With new web resources coming online constantly, this will be a real time-saver.

Books

There is an enormous literature in art history and it may at times be overwhelming to try to make your way through it as you work on your paper. Because there's so much popular publishing about art, you want to be careful to evaluate your sources for their quality and relevance to your work. Although it's not an absolute

guarantee of scholarly merit, look for exhibition catalogues published by major museums and books published by university presses. These have the highest scholarly standards and the most rigorous editorial process and so will likely be the best resources for your work.

There's no absolute standard cut-off for dates of your sources or how old they are. There are classic works that still contain many insights that are forty or fifty years old—or even older. One general guideline to the quality of an older publication is to see how often it's cited. If you see it in lots of bibliographies, then you should probably take a look at it too. It's also absolutely essential to consult the most recent scholarship on a subject. If you're unsure about the scholarly merit of a book, you have several options. You can, of course, ask your instructor or a research librarian about it. You may also want to look up reviews of the work in major journals. I recommend looking up more than one review—you don't want your perspective on the book skewed by reading one review that happens to be unusually hostile or positive.

As you research, it's important to keep in mind the distinction between primary and secondary sources, because each gives you different kinds of information on your subject. Primary sources for historical research are those sources produced by people directly involved in the images, events, and time period you're writing about. So, for example, the letters of Mary Cassatt (1845–1926) are a primary source for understanding her art. Secondary sources are by scholars and others commenting on or interpreting the images, events, and time period you're writing about. The art historian Griselda Pollock's book *Mary Cassatt: Painter of Modern Women* (London: Thames & Hudson, 1998) is a secondary source about the artist. Many primary sources have been published—artists' letters and other writings, for example—and so will be readily available to you. Other primary sources are unpublished and will be inaccessible without going to the libraries, museums, and archives that house the

original items. Instructors typically don't expect under-grads to utilize unpublished primary sources in their research papers.

There are many types of specialized publications within art history. These are a few that you may run across:

Exhibition catalogue. Catalogues often contain recent scholarship in the form of essays by leading scholars in the field. Over the past twenty years or so, exhibition catalogues produced by major museums have become important works of scholarship.

Monograph. This type of book focuses on a single subject or on the work of a single artist.

Catalogue raisonnée. The complete catalogue of an artist's work, often including extensive entries on each work, tracing its collection history (provenance) and comment-ing on its significance.

Festschrift. A collection of essays celebrating a famous scholar (often upon retiring). Students and colleagues contribute essays that often address or were inspired by the honoree's work.

Corpus. This term (pl. corpora) comes from the Latin term for "body." A corpus publishes all the objects of a known type. One of the best known is the *Corpus Vasorum Antiquorum*, a multivolume work that publishes images and catalogue information for all the known Greek painted vases.

Periodicals

Periodic literature is important because this is often where scholars publish new ideas first. As with books, there are so many periodical publications on art that sorting them out can be a bewildering process. Glossy art magazines geared toward collectors, dealers, and interior designers are often very appealing, but they are typically written by professional journalists rather than art historians and so are somewhat limited as scholarly resources. While such periodicals can be useful (especially if you're writing about collecting practices, for example), your best bet is to work with scholarly journals

for most subjects. Some of the most important scholarly journals in art history are listed in the bibliography of this book; these are the journals to consult first. These journals have a demanding review process for all the articles they publish and their authors are usually highly trained art historians.

There are a number of guides to periodic literature available online or in print. Online guides will typically be available from your university's website (and may require a password), while print guides are usually kept in the library's reference section. The major online guides go back about twenty years and should be perfectly adequate to support your research on most topics. As with books, there's no magic cut-off date for when something is relevant. Certainly you want to get the most up-to-date articles, but there are also classic articles written many years ago that are still useful. If your topic is very specialized, or if you're doing something historiographic (focused on the history of art history), then you will certainly want to cast a wider net and consult the printed guides to periodic literature to get a good sense of the earlier literature. Some online guides now offer full texts of articles, but they sometimes don't include images, so for art-history articles you may still need to go to the stacks and get the print versions. Also, be aware that the most recent issues of periodicals won't be included in databases, so you'll need to check those that relate to your topic in the library to see if they include anything on your subject.

The online index that I find most useful is Wilson OmniFile Full Text Mega, a multi-disciplinary database providing the complete content (indexing, abstracts, and full text) from several databases in the sciences, social sciences, the humanities, business, and education. It includes Art Abstracts from 1984 to the present, and the Art Index, the forerunner to Art Abstracts, from 1929 to 1984. Wilson is fairly flexible and provides a number of search options. Given the interdisciplinary nature of art history today, I recommend using the broad, inclusive search function, because it includes both the art history databases as well as other humanities and social sciences.

Another good online resource is the BHA (Bibliography of the History of Art), which is also available in print version. It includes two earlier indices: RILA (Répertoire international de la littérature de l'art) and the Répertoire d'art. Keep in mind that BHA covers only Western art since Early Christian times. Both Wilson and BHA include abstracts of their more recent material, which can be helpful in determining if a source relates to your subject.

Two other specialized databases may prove useful. ARTbibliographies MODERN began in 1974, and in 1989 it discontinued covering nineteenth-century art and began focusing exclusively on twentieth-century art, design, and photography. It includes extensive annotations and cross-references. The Avery Index to Architectural Periodicals is also available online and is a very good supplement to the more limited coverage of architecture in the general art indices. Be aware if you're researching non-Western topics—especially in African, Pacific, Native American, or pre-Columbian art—that you will probably have to go beyond art-history databases, which is why Wilson is so useful as an interdisciplinary database. You may find relevant articles about African or Native American art in social-science databases, for example, because anthropologists have also written about these art traditions. Archaeological subjects, from Asia, the Classical world, and the pre-Columbian Americas, may show up in social-science databases because archaeology is often considered a branch of anthropology.

Websites

Although the web offers a lot of good material you may not find anywhere else, you will not be able to write an entire paper from research conducted exclusively on the web. There is a tremendous amount of valuable scholarly material that has not been put up on the web, and it may be years before these things are available online, if they ever are. For the foreseeable future, you'll have to plan on doing some old-fashioned library research.

Be sure to evaluate websites carefully; remember, just about anyone can post a website. In general, sites

developed by museums, libraries, and universities are reliable and good resources—although, like any other source, the information they provide must be critically evaluated. Be very skeptical of anything posted by an individual, unless you can verify that that person has credentials that make him or her a recognized authority on art history (e.g. a PhD from a reputable university, a teaching position, a museum position, or staff position at a major periodical).

It's easy to waste a lot of time on the web. For research papers, I generally don't recommend doing a basic web keyword search through a commercial search engine, like Google or Yahoo, unless you have lots of time, or are doing the search for fun when you wouldn't do other kinds of research or productive work. If you don't do a sophisticated and targeted keyword search, it will take you a lot of time to work your way through the results, which could easily number in the thousands. Instead, check out art-history hub sites, which primarily offer links to other sites and usually provide some kind of minimal assurance of quality (some good hub sites are listed in the bibliography). Within those sites, focused keyword searches can help you find the information you need. If you're studying a particular work of art, then go the website of the museum that houses it.

Reference works

The bibliography lists a number of art-history reference works that may help you in your research. Dictionaries of artists or of symbols and subjects in art can be very helpful as you begin your research. I want to mention in particular the *Grove Dictionary of Art* (ed. Jane Turner, Macmillan, 1996), which is an excellent resource, with articles written by major scholars in the field (your library may subscribe to the online version too).

Keep in mind that references like the *Encyclopedia Britannica* are not usually acceptable resources for a college-level research paper because the articles are usually too general. You should feel free to consult a general encyclopedia if you need some background

information on a particular topic—if you're writing about a Japanese scroll painting, for example, and don't know much about Zen Buddhism. Your paper should be specific enough in its arguments, so the kind of material presented in a general encyclopedia isn't something that you would need to quote.

Critical moments in art-history writing

I'll address here some of the specific challenges you'll face in writing art-history papers. Remember to consult one of the standard writing guides listed in the bibliography to get help with more general issues in writing.

Developing a thesis

It's not easy to write a simple, clear thesis, much less actually figure out what your thesis is. When I was starting my PhD dissertation (let's face it, a really big paper!), I found myself going on and on whenever anyone asked me about my topic. A student from another university told me that her advisor recommended first writing a page-long statement of what the dissertation was about, then a paragraph statement, then a three-sentence statement, then a one-sentence statement. In this way she distilled the basic issue she was exploring in her research. This is the way the development of ideas goes. We have this notion of the light-bulb going on in our heads, coming to a sudden brilliant insight that we go out and prove. Actually, I think the process of coming up with an idea is more like panning for gold. We have to sift through a lot of stuff before we come up with the valuable nugget we want. It is a process of constantly refining our thoughts so that the really good, original ideas emerge.

When you're writing a substantial paper, there are actually several stages to developing a thesis, as the sample research on Artemisia Gentileschi above showed. The first is to develop working hypotheses to guide your research. You may want to write down a list of these initial questions. Once you've accumulated a substantial body of research, read through your notes to help

crystallize themes or issues that you want to address in the paper. One of the original questions that prompted your research will probably emerge as the basis of your thesis. During the editing process, when you're working with the first rough draft of the paper, make sure that you're stating the thesis clearly at the beginning of the paper, in the introduction. Even though, as an undergraduate, you're probably working mostly with secondary sources, your thesis should be original—this is your idea, not just a rehash or summary of someone else's ideas on the subject.

Here are two examples of introductory paragraphs from student papers on African art. Both were produced for an assignment asking students to write about a work of African art on display at a museum. Neither student is a particularly strong writer; both choose the same strategy to open the paper, by providing some general background information about the culture. Despite these similarities, only one provides a clear thesis. The first paper begins:

> The Cameroon grasslands consist of many kingdoms, chiefdoms, and villages, which are independent. These villages are mainly self-governing. The Cameroon grasslands consist of important kingdoms. The important kingdoms of the east include Bamum, in the south the Bamileke, and in the northwestern highlands, the Kom, Bali, N'so, Oku, Aghen, Bafut, Mankon, and Babanki-Tungo. There are stories from migration history that imply that the groups arrived in what are now Cameroon grasslands from the region of Tikar to the east. This is believed to have happened from the sixteenth to the eighteenth century. There were many trade routes that crossed the paths of other trade routes, carrying people, artwork, and ideas. The arts of the Cameroon can be characterized by traditions of gift giving.

The second introductory paragraph reads as follows:

> The Yoruba culture in Nigeria exhibits many traditional elements that stress the relationships between the different realms of existence: spiritual, human, and natural. Through the Egungun traditions, which include Gelede, the Yoruba people emphasize their relationship with the dead who, in

return, offer the living a "good" life, which ensures stability, prosperity, and happiness. Indeed a cyclical process of fertility, birth, prosperity, and death is performed through the acts of ancestor worship. In Yoruba culture, there is a male society, known as Gelede, that emphasizes female reproductive powers through annual performances during the pre-harvest season (March to May). The rituals are practiced through a number of performance rituals, such as singing, dancing, drumming, and costume. Usually performed in the afternoon, Gelede rituals are accompanied by wonderful masquerades, which characterize Gelede tradition. Carved wooden masks, such as the nineteenth-century mask at the William Benton Museum of Art, were worn at ritual performances to represent social, spiritual, satirical, and commemorative values of Yoruba culture.

The second writer succeeds in bringing the general discussion of Yoruba culture around to the artwork she's writing about, and then presents a clear perspective on that piece in her thesis. The first writer doesn't mention the artwork she's dealing with at all in this introduction, and, in fact, struggles later in the body of the paper to deal directly with the work. If she had focused on writing a clear thesis statement about that object, it would have helped her anchor the rest of the paper. In the editing process, then, she could constantly go back and check her work against that thesis statement, to make sure that she was dealing with the object and developing her argument in effective ways.

Writing an introductory paragraph

It's no wonder that students often struggle with introductory paragraphs. There's a lot riding on the introduction: you have to get the reader's attention, explain your subject, and set up your argument so that you can develop it effectively in the body of the paper.

I often recommend that students save the writing of the introductory paragraph for the end of the first draft. You should have a strong thesis and an outline to guide you in writing the body of the paper, so there's no reason for you to start with the first paragraph of the paper.

If you want, draft out a very rough version of the introductory paragraph, but don't spend a lot of time on it. Once the rough draft of the body of the paper is written, then go back and write the introduction. Having written the body, you'll know more accurately what the paper is about; even with the best of outlines, your paper will change as you write, because writing itself is a process of thinking and exploration. Also, your having already produced pages of writing in the body of the paper will remove some of the anxiety that comes with the writing process. With the end in sight, that important first paragraph will be easier to produce.

There are many different ways to handle the introduction to a paper. A direct and effective way is simply to introduce the artworks or issues you are studying and then state your thesis, your point of view on them. Such introductions often work from some general observations to the specific thesis, as in this example:

> Masks and costumes have long played a role within cultures all over the world. In many past and present cultures of Africa, masks take on a very important position in both social and cultural contexts. The Kuba people (also referred to as Bushoong), located east of the Kongo heartland in the Democratic Republic of Congo, behold masks not only as objects of beauty, but also as integral components of social life. Most often worn by dancers in public ceremonies, initiation celebrations, or rituals concerning the sacred king, the masks invoke myths of creation and history. The Mask of the Babembe Society is just one of over twenty different mask types considered in Kuba culture as embodiments of spirits (Hahner-Herzog 1998, 82). This mask expresses important spiritual and cultural beliefs of the Kuba in both its form and function. Through its physical makeup and performances in initiation and royal ceremonies, the mask addresses the importance of the institution of kingship and dynastic influences on origin and myth, spiritual government, and aesthetic enrichment among the Kuba.

Sometimes students choose to write more creative introductions, reflecting on a quote or dictionary definition or an excerpt from a poem or favorite novel. They

may use the first paragraph to recount their personal experience in pursuing the topic. I've noticed especially in formal-analysis papers that students often recount their experience of the museum visit to provide a context for the formal analysis that then takes up the body of the paper. I tend to regard this as a valid option, although some instructors consider this kind of introduction to be extraneous. If you want to use this kind of opening, it's probably best to check with your instructors, and remember that you must still make the transition to the body of your paper by introducing your research topic and stating your thesis.

Here's one example of this kind of opening to a paper that discusses a work in the Boston Museum of Fine Arts. It's long, but I want to quote it here because it's ambitious—the writer is taking a self-conscious literary perspective on his experience, so it will give you a sense of how this kind of introduction can work. The introductory personal narrative actually starts out by playing off a quote from a popular travel book about Italy:

> As the sun brightens, the land spreads out a soft spectrum: the green of a dollar bill gone through the wash, old cream, blue sky like a blind person's eye. The Renaissance painters had it just right. I never thought of Perugino, Giotto, Signorelli, et al., as realists, but their background views are still here, as most tourists discover, with dark cypress trees brushed in to emphasize each composition the eye falls on. Now I see why the red boot on a gold and blonde angel in the Cortona museum has such a glow, why the Madonna's cobalt dress looks intense and deep. Against this landscape and light, everything takes on a primary outline. Even a red towel drying on a line below becomes totally saturated with its own redness.
>
> Frances Mayes, Under the Tuscan Sun

Although the sky may not have been "saturated with its own cobalt" and the fiery orange leaves did not take a "primary outline"—an effect one would most certainly experience in Italy—the bright fall sun, the leaves, watercolor hues of red, orange, and yellow, and the crisp clean air, however, did

form the ambiance of a Walt Whitmanesque brilliant New England autumn day when my roommate, Chris, and [I] began our journey to the beautiful city of Boston, Massachusetts and the Museum of Fine Arts.

To our good fortune, our drive was rather uneventful. However, intermingled between shout choruses of our favorite John Cougar Mellencamp tunes and my pep talks reassuring Chris that, although he is a journalist, he would enjoy the museums, I was left with my own contemplative thoughts. To be honest, I wasn't really sure what it was I was looking for. I had never been to the Boston Museum of Fine Arts before, let alone with the definitive mission of finding an inspiring piece of Renaissance art. Was I going to be moved by a panel painting? Perhaps a Madonna and Child? I doubted it. Or perhaps I would see a fine piece of sculpture. I had always been intrigued by the interesting relationship between the space created by the sculpture and the negative space that surrounds it. However, before my questions could be answered, a much more important goal was at hand: parking.

This text mixes humorous observations and serious issues. The journey to the museum provided the writer with an opportunity to reflect on the intellectual journey he was taking in art history. The writer went on to describe his experiences in the museum, looking at different works, until he found the one he wanted to write about:

After a time of pure enjoyment of the visual splendor of the image, I allowed myself to stop looking, and read the label:

Presentation of the Virgin in the Temple. Fra Carnavale (Bartolomeo di Giovanni Coradini). Oil and tempera on panel. Santa Maria della Bella, Urbino, 1467.

I found this most peculiar, for I had not even really noticed the Virgin at all. Puzzled, I took a second look. It is then that I realized that the small cluster of women at the bottom of the painting, one dressed in a rich, blue dress, was the Virgin and her attendants. Although my question temporarily had been answered, other questions arose. Why was there such a secular treatment of an apparently non-secular topic? And what was really the focus of this painting? Upon further specific analysis of the image it

became apparent to me that the actual subject, "Presentation of the Virgin in the Temple," is actually a secondary topic. Perhaps I could even more boldly state that the subject of the Virgin is not even crucial to the painting at all. Rather, Fra Carnavale was exploring the world of perspective and balance in this painting, and created an image that gives the illusion of having as much structure and space [in it] as any sculpture or architecture.

In this way, the writer used the story of his own journey to the museum to reflect on the purpose of the assignment and to show how he came up with his thesis statement.

As an aside, I'll point out that in the editing process, the writer should have deleted the Frances Mayes quote. The paper is about structure and space and spatial illusion—even the writer's observations about the appeal of sculpture in the opening paragraphs relate to this issue—but the Mayes quote is primarily about color. Although this quote was probably a very effective springboard into the writing process, in the final version of the paper it doesn't really help him set up his argument. I'll also note that this writer produced a paper that exceeded the page requirements for the assignment; he didn't use this long introduction as an excuse to do less research or write less about the painting.

Sustaining the argument

Especially with a long research paper, it's easy to get off topic in the body of the paper. You want the body of the paper to be a like a string of beads—one leading to the next, creating a unified whole. Each paragraph should have a point to make, and that point should contribute to supporting and developing the idea presented in the thesis.

One way to ensure that you do this is to make a substantial outline of the paper before you begin to write. This will help you stay on track, even if you end up changing and modifying your ideas as you write. If you really hate making outlines, then you'll have to leave time for an extra rigorous editing process. Read each

paragraph critically to make sure that it has a clear topic sentence that supports the paper's overall thesis. Make sure your ideas are supported by detailed visual and contextual analysis. Also make sure that you're developing the argument in a way that makes sense, putting the paragraphs in order so that they flow logically.

In the editing process, be on the lookout for purely descriptive passages. Make sure your text is consistently analytical and interpretive, and that any formal analysis you provide isn't there just for its own sake but to support your argument. Don't supply endless, irrelevant contextual background information—keep to the point. Be specific in what you say about the image, the culture, its context, and the historical period; you should avoid generalizations.

Dealing with intentions

When you're engaged in the development of a complex interpretation of a work of art, it's sometimes difficult to address the artist's intentions. You create a certain understanding of the work; but was that the artist's understanding of her work? What were the artist's intentions? Were the kind of representational dynamics you're discussing fully self-conscious?

Sometimes your interpretation will be conjectural. Remember that in writing history your evidence is fragmentary at times, and that there aren't always direct answers to the questions you're asking. At the same time, what you see is inevitably shaped by the present. These conditions of history must be reflected in your writing. As the historian Greg Dening observes, "Our narratives also present something. They are ostensibly about something past, about something that has happened. But they are also the medium of our present relationships. Our stories are as much about us as about something else . . . History is not the past. It is the past transformed into something else, story."

For example, I have already noted how art historians often relate Artemisia Gentileschi's many depictions of the biblical heroine Judith to her experience of rape. To

what extent does this reflect our own cultural attitudes toward sexual assault and assumptions about how to respond to such an experience? Gentileschi did not leave any statements to this effect, nor did any of her associates or contemporaries. We can't really know the extent to which this interpretation represents Gentileschi's own conception of these images, her unconscious conception of these images, the perception of her patrons, or simply our own take on it, from our own cultural vantage point. The challenge here would be to write a forceful and convincing account of your argument without using language that unfairly attributes your particular perspective to Gentileschi or her contemporaries.

The conclusion

Conclusions can be really hard to write. By the time the paper is ready for a conclusion, you're exhausted, you've had enough, and the temptation is to just stop and leave the thing alone. As understandable as these feelings are, you would be shortchanging your work by not bringing it to a proper end. There are different ways to handle conclusions. Summarizing key points of the argument can be simple and effective. You may also use the conclusion to extend your argument by pointing to other issues or ideas that don't belong in this paper, but that you might deal with in another paper or at another time. A third option is to do something creative that expands your work in a new way.

As an example, here's a conclusion to a student paper about the Roman emperor Constantine (reigned 306–337) as patron of Christian churches:

> Perhaps it is fitting then that in his death Constantine was treated as a great Roman emperor. It is true that on his deathbed he finally officially converted to Christianity, but his funerary services followed the Roman tradition. Upon his death in 337, the people of Rome "raised him among the gods," pagan gods, by honoring him in a painting that shows him "above the vault of Heaven resting in his celestial abode" (Krautheimer, *Capitals* 39). Thus even in his death Constantine continued to walk the line between

paganism and Christianity, and practiced a little of both. Conservatism and adherence to tradition made Constantine a successful emperor, and though he was the first Roman emperor to become Christian his actions prove that he would not hesitate to above all identify himself as a Roman.

The writer effectively uses Constantine's death to close the paper and summarize the key point—that Constantine can be thought of as both pagan and Christian, despite his extensive patronage of Christian churches. Notice that the writer summarizes her interpretation and then extends it to consider the treatment of Constantine's death. She does not unnecessarily summarize all the supporting points or the formal and contextual analysis that developed the argument in the body of the paper.

Editing

One of the hardest things for me to do when I've finished a piece of writing is to go back and edit it. Usually, I'm tired at that point and not feeling very creative. And confronting all the awkward and unclear sentences I've written isn't exactly fun. If you have the time, it's a good idea to take a break before editing—a day or two (or at least a short walk)—to clear your head and get some perspective on your work. It's also a good idea to trade at least one round of editing with another student in the class. Someone else will be able to see problems that you don't because you're too close to the work.

I'll share with you how I work—like writing, everybody practices editing a little differently, and you'll have to find the process that works for you. I use a printout for this process because it's hard to get a sense of the paper as a whole from the screen. I go through first and try to edit for ideas and for the basic structure of the argument. This means checking whether I have a clear thesis; whether each paragraph develops that thesis; whether each paragraph follows from the next; and whether each paragraph is coherent, developing one idea and having a strong topic sentence. I check to see that I'm providing

all the evidence I need to support my argument. Often I find I have to reorder paragraphs (I number them in the margin), and sometimes part of one paragraph really belongs in another. At this point I mark text edits—for example awkward phrases, poor word choices, grammar, and spelling—as I see them, but not systematically. Then I go back to the screen and work my way through my edits. Before starting, I copy my text into a new computer file, so that if it gets hopelessly messed up and I need to start again, I still have my original rough draft to go back to.

When that round of on-screen editing is done, I'll make another printout and go through it again. I often read the work aloud to make sure that it makes sense and flows smoothly; you may even want to get a friend to listen to you read it, too. I do as many printouts as I need to edit the paper, and on the final one, I concentrate on things like grammar, spelling, and word choice. Don't rely completely on the grammar and spell-check tools built into your word-processing program. They typically won't catch errors with homonyms, such as the use of "there" instead of "their," or incorrect usages, such as "incumbent" instead of "recumbent." There are lots of little tricks for editing, and you should experiment to see which ones work for you. If, for example, you often confuse "it's" and "its" when you're writing, editing will go more quickly if you use your word processor's search function to find each instance. To speed up the process of checking your parenthetical references, use the search function to find each opening parenthesis—you will be less likely to miss a reference this way. If you tend to write sentence fragments (with no verb), reading your paper backward sentence by sentence can help you spot them.

Citations and bibliographies

Formatting citations correctly is a pain. Unfortunately, it's critically important to the scholarly integrity of your work, so you really have to do it right. It's beyond the scope of this book to provide exhaustive guidelines for

formatting citations and bibliographies (there are whole books dedicated to doing just that), so I'll review some very basic information to help you get started. Art historians usually format their citations according to either the MLA (Modern Language Association) Style Guide or the Chicago Manual of Style. Your instructor will probably indicate a preferred system, although it's up to you to use that system correctly. Your college writing center may have a website providing guidelines to citation styles; also check the printed references in the bibliography.

MLA citations

The MLA form for citations is a parenthetical reference system: that is, sources are cited in parentheses at the end of the sentence, inside the ending punctuation. The format is relatively simple:

(author page number)

as in

(Smith 179)

If a work has two authors, list both, joined by the word "and," and the page number:

(Joppien and Smith 124)

For multiple authors, list the name of the first along with the Latin abbreviation et al. (et alii, or "and others"):

(Chin et al. 89)

If you're citing two different authors with the same last name, include their first initials:

(D. Renaldi 35)

(R. Renaldi 98)

If you're citing more than one work by the same author, include a word or two from the title to distinguish between them. For example, if you were citing Bernard Smith's *European Vision and the South Pacific* and his *In the Wake of the Cook Voyages*, you might cite them as (Smith, Vision 209) and (Smith, Wake 46).

Chicago citations

In the Chicago system, citations appear either at the bottom of the page (footnotes) or in a list at the end of the paper (endnotes), before the bibliography and illustrations. Instructors usually allow students to use endnotes, so I'll discuss that form here. Your word processor should help you format endnotes automatically, with a number appearing in superscript after the end punctuation of the sentence, like this.[1] The endnote includes the same number then lists the work and page number of the source material. The first line of each note is indented five spaces from the left margin, and the notes are usually single-spaced with double-spacing in between. The endnote format varies slightly, depending on the nature of the source:

Book	1 Author's name, *Title* (place of publication: publisher, year of publication), page number of reference.
Journal article	1 Author's name, "Title of Journal Article," *Title of Journal* volume number of journal (year): page number of reference.
Book chapter	1 Author's name, "Title of Chapter," in *Title of Book*, ed. Editor's first and last name (place of publication: publisher, year), page number of reference.
Newspaper article	1 Author's name, "Title of Article," *Newspaper*, date [day month year], section number if applicable, page number. [If there's a section number, then insert "p." before the page number for clarity.]
Unpublished thesis	1 Author's name, "Title of dissertation or thesis" (Ph.D. diss. [or "M.A. thesis"], University, date), page number.
Website	1 *Title of Website*, author or editor if known, sponsoring institution if any, date you consulted the website <website address>.

After the first citation for a particular work appears in the endnotes, the format for referring to that work in lateritations is shortened:

If you're using only one book or article by that author	22 Author's surname, page number.
If you're using two or more works by that author	22 Author's surname, shortened title of the work, page number.
If you use two authors with the same last name	22 Author's full name, page number.
If you not only have two authors with the same name, but two works by one of those authors	22 Author's full name, shortened title, page number.

When you follow a citation with another one referring to the same work, use the abbreviation "Ibid." (Latin for "the same place") for the second reference. If the page number changes, include the page number. A typical series of endnotes might look like this:

1 Annie E. Coombes, *Reinventing Africa: Museums, Material Culture and Popular Imagination in Late Victorian and Edwardian England* (New Haven: Yale University Press, 1994), 110.

2 Ibid.

3 Ibid., 122–3.

4 Monica Blackmun Visona, ed., *A History of Art in Africa* (New York: Harry N. Abrams, 2000), 245.

5 Coombes, 112.

6 Babatunde Lawal, *The Gèlèdé Spectacle: Art, Gender, and Social Harmony in an African Culture* (Seattle: University of Washington Press, 1996), 168.

7 Babatunde Lawal, "Relating the Past to the Present," *African Arts* 34 (2001), 88.

8 Visona, 244.

9 Lawal, *The Gèlèdé Spectacle*, 89.

If a single paragraph of your paper contains several references from the same author, you can use one number after the last quotation or paraphrase from that source to indicate the source for all of the material used in that paragraph.

Bibliography or Works Cited

Both MLA and Chicago use a similar system for listing, at the end, all the works cited in the body of the paper. We

If you experience writer's block

You're choking. You can't get the paper written. You stare at a blank screen, an empty sheet of paper. Writer's block is usually a short-term condition that stems from being tired and stressed out (as you typically are when you're writing a paper!). Here are some solutions.

Before you start to worry that you'll never write another word again, take a break. Stand up, stretch, go for a walk, call a friend, get something to drink. That might be enough to refresh you and jump-start the writing process.

If I'm under a lot of time pressure but can't seem to write, I'll often switch gears for a bit. Rather than taking a substantial break, if I can't afford the time, I'll stop writing and work on formatting the bibliography, footnotes, or illustrations. This way I'm still making progress, but getting the break I need from writing.

Subdivide the writing project into manageable blocks. Instead of thinking about the whole ten-page paper that has to be written, think about a small section of it. Set yourself the task of writing one page, or one paragraph, or even just one sentence. If you have an outline (which you should!), think about the paper in those sections, piece by piece, rather than as a whole. Or set yourself a time or word limit: write for half an hour, or fifteen minutes even, and then promise yourself a break after that, or after producing a certain number of words. I'll admit that when I was about a third of the way through this chapter, my energy was flagging and I felt like I just couldn't finish it—it was the last chapter that I had to write to complete the book. So I set myself a goal of writing a certain number of words per day and promised myself that I could go home once I had produced those words.

The possibility of going home early was a big incentive, because I'd been spending long hours at the office working on this project. It was enough to get me over the hump, so that I finished by the date I had set myself. My routine had become stale, and simply changing my working process (writing not a certain number of hours per day, but a certain number of words per day) gave me fresh energy.

Have realistic expectations, especially for a first draft. Free yourself from the idea that your writing has to be perfect. If you expect yourself to produce polished prose from the very first word of a paper, that level of pressure is going to make it awfully hard to write anything at all. Just get something down on the page. Even if you edit it to pieces later, or even delete the whole text, just start writing.

Talk with a friend about your paper—sometimes it's easier to verbalize your ideas than to write them down. Write down a summary of the conversation, or even have your friend jot down some notes while you talk. You also might try writing an email to a friend describing the paper.

If none of these tactics is working for you, then set up two appointments: one with your instructor, the second with a tutor in the writing center at your college. You may have a more serious problem than writer's block—maybe your thesis is weak, or you've gone down a wrong track with your research. Of course, this solution isn't going to work well if you're writing the paper the night before the due date. This isn't generally a time when instructors take writer's block seriously; unfortunately, it ends up sounding like just another excuse for an unfinished assignment.

often call this list the "Bibliography," although, technically, a bibliography is an exhaustive list of all the works on any given subject, so your list is more accurately called "References" or "Works Cited."

Organize the Works Cited alphabetically by author's last name, and use periods (rather than commas, as in the endnotes) to separate items. If a work does not have an identifiable author, then alphabetize it by the title. If you have more than one work by an author, then use dashes (———) after the first item in place of the author's name. Book entries do not include any page references, while book chapters and journal article listings should include full page numbers for the chapter or article, not the specific pages referenced in your text. Single-space the entries and double-space between them. Use hanging indents to format bibliographic entries: begin the first line at the left margin but indent all subsequent lines five spaces. Here's how the sample endnotes listed above would appear as a Works Cited list in either the MLA or Chicago system:

Coombes, Annie E. *Reinventing Africa: Museums, Material Culture and Popular Imagination in Late Victorian and Edwardian England.* New Haven: Yale University Press, 1994.

Lawal, Babatunde. *The Gèlèdé Spectacle: Art, Gender, and Social Harmony in and African Culture.* Seattle: University of Washington Press, 1996.

——— "Relating the Past to the Present." *African Arts* 34 (2001): 88–89.

Visona, Monica Blackmun, ed. *A History of Art in Africa.* New York: Harry N. Abrams, 2000.

Plagiarism's gray zone

Reviewing citation formats brings up the issue of plagiarism. By definition, plagiarism is the deliberate presentation of another person's work as your own, by, for example, buying a term paper off the web or copying long passages from a published work without citing it. That kind of plagiarism doesn't concern me here—I'm sure you know why you shouldn't do it—so much as unthinking plagiarism, the way that it's easy to cross the

sometimes fuzzy boundary between your work and someone else's. The problem for instructors is that we have to treat unthinking plagiarism as true plagiarism, so you want to be very careful in citing sources. To my mind, it's better to be over careful and have your instructor note on your paper that you don't really have to cite something, than to leave out a necessary reference.

Students often get into trouble with paraphrasing, thinking that if they put the idea in their own words that it doesn't have to be referenced. But just changing the wording around doesn't make an idea your own. Take this passage, from a book about feminist artist Miriam Schapiro (b. 1923), discussing the 1970s, when she came to prominence as an artist:

> The studio became Schapiro's room of her own and, at moments of great personal conflict, the only connection with her creative self. It was a place away from the kitchen: "daily routine relieved with beauty." She held on to this space and made time to occupy it even though she, like other women artists, spent as much time away from her studio as she spent in it.
>
> (Thalia Gouma-Peterson, Miriam Schapiro, Linda Nochlin, *Miriam Schapiro: Shaping the Fragments of Art and Life*, New York: Harry N. Abrams, 1999, p. 21)

Say you paraphrased that passage in a paper:

> Schapiro's studio was "a room of her own," à la Virginia Woolf, the place she connected with her creative self, especially at moments of conflict. This was her space, and she spent a lot of time there, even though, like other women artists, she also spent a lot of time away from it.

The wording has changed considerably, but the basic idea has not, and you would have to cite the book. Although the paraphrase recognizes Virginia Woolf as the source of the expression "a room of her own," that doesn't make it an original thought about Schapiro—the original authors clearly know the (very famous) origins of that phrase.

Plagiarism, like citation format, is a complex subject. I suggest that you consult your writing center or the writing guides listed in the bibliography for more information.

Writing style

How do you write so that the words on the page sound like you, and are distinctive from the writing of other people? A writing voice is something that develops with time and practice. Your main goal at this point should be to produce clear and grammatically correct text. This foundation will enable you to develop a distinctive writing voice of your own.

Common stylistic pitfalls of art-history writing

Very long paragraphs (a full page or longer). Usually this means the arguments are muddled and you're trying to make more than one point at a time. You can probably restructure a very long paragraph as two or more paragraphs.

Very short paragraphs (one or two sentences). This means either that your thoughts are not fully developed and you need to expand that paragraph, or that the material should be integrated into the paper elsewhere.

Unfocused paragraphs. Make sure each paragraph has a point to make and isn't just a jumbled collection of miscellaneous observations that don't seem to fit anywhere else. Does the paragraph have a topic sentence? Does each sentence in the paragraph support and develop that idea? If not, then edit.

Passive voice. Active verbs are more forceful and expressive than passive verbs. A paragraph full of passive verbs sounds stilted and monotonous.

> *passive* The fresco was painted by Michelangelo.
>
> *active* Michelangelo painted the fresco.

Verb tenses. Use consistent and correct tenses throughout your paper. This doesn't mean that the verbs will all be one tense. Art historians typically use the present tense to describe visual or physical aspects of an artwork: "the Buddha sits in a yogic posture," "the columns support the pediment." Use the past tense to discuss the actions and thoughts of a deceased artist: "Picasso lived in Paris."

Long, convoluted sentences. Douglas Fraser, who taught art history at Columbia University before I enrolled there for

my PhD, used to tell his students, "Take your favorite sentence and rewrite it, the simple way." His students passed on this advice to me, and I still follow it when I'm editing a first draft. My favorite sentences usually turn out to be the really long, complicated ones—the kind that I ultimately split into two (or even three!) clear, succinct statements.

Strings of prepositional phrases. These are especially difficult to avoid in formal analysis.

awkward	The family sits around a table with flowers in a vase on top of it.
better	The family sits around a table decorated with a flower-filled vase.

Expletive constructions ("there is," "it is"). They bulk up sentences, so watch out for them in the editing process:

awkward	It was the last image in the manuscript that was the most striking.
better	The last image in the manuscript was the most striking.

Strong verbs. Make your verbs active and precise. Avoid, when possible, bland verbs like "is," "has," and "goes." Streamline your verbs (for example, replace "has an affect on" with "affects").

"Five dollar" words. One of my high-school English teachers used to give us a hard time for using a "five dollar" word when a "one dollar" word would do. (I'm sure I was one of the worst offenders—I was constantly rooting around in the thesaurus looking for new words to use in my weekly essays.) Explain your ideas in your own way, avoid flowery expressions, and steer clear of words if you aren't sure what they mean. At the same time, don't be afraid to use terms that help you explain your argument with precision—if you know how to use "contrapposto" or "impasto" correctly, then do.

Finding a voice

In developing a writing voice, you have to focus on putting things in your own words. Don't use too many

Putting together (those damned) illustrations

Just when you think you're finally finished with an art-history paper . . . there are the illustrations to assemble. (When I was a student, this was the moment that I usually started fantasizing about switching my major to English.) Your instructor will probably give you some guidelines about how she wants illustrations formatted, but I'll outline here a good basic format that will generally be acceptable.

It's best to scan the illustrations directly from books and then create illustration pages in a word-processing program by inserting each image file on a separate page. At the bottom of each page, give the image a figure number that corresponds to its figure number in the text, and include basic caption information: artist name, title, date, medium, culture, museum collection or location (e.g. list city and country for a building). As an alternative to scanning, you can photocopy the images, cut them out, and then tape or glue them to illustration pages that you've already printed out with the relevant caption information.

It's a nuisance for instructors when students just take their working photocopies, with whatever random bits of text happen to be on them, scribble figure numbers on them, and stick them at the back of the paper. This can make the images difficult to interpret and understand in relation to the text of the paper—not the best way to support your argument (or make your long-suffering instructor's work easier!).

Remember to keep good photocopies of images as you do your research, so that you're not scrambling to reassemble your sources and find pictures at the last minute. Write the source of the image on all photocopies as you make them.

long quotations, and don't paraphrase lazily so that the words on the page still end up sounding like someone else. You can also try reading your work out loud when editing—this allows you to check the flow and to see if you would actually "say" such a thing in another context. (This technique will also help you catch grammatical errors and sentences that don't make sense.) It also helps to produce other kinds of writing. If you want to be a good writer, then keep a journal, write short stories or poems; even writing lots of email can be helpful.

A note about my writing style: the writing voice I'm using here is casual—the text sounds almost as if I were talking with you in class or my office. I think this style

makes the kinds of things I need to say in this book more easily understandable. However, this isn't necessarily a writing style suitable to every writing project. It's generally not appropriate, for example, in research papers, where contractions ("weren't" instead of "were not"), slang, and a strong first person voice usually aren't acceptable.

Conclusion

Writing takes practice. You can't become a good writer without writing—a lot. Learning how to write in the style of a particular academic discipline isn't easy, because each discipline has its own distinctive way of researching, structuring arguments, and presenting evidence. This chapter has given you some guidelines for art history's expectations in these basic areas. Writing as an art historian will teach you to look carefully, argue logically, and think originally. Remember that in the end all writing, not just fiction or poetry, is a creative process.

Navigating art-history examinations

Well what is the answer? But, what, then, is the question?
Gertrude Stein, writer (1874–1946), on her deathbed

Few people truly enjoy taking tests. And if you don't understand the goals and methods of the examination, and your studying process isn't right, then instead of being a good opportunity to consolidate your knowledge, a test becomes a frustrating, unpleasant experience that can turn you off a subject for good. This chapter will teach you how to prepare for art-history exams, which typically test your knowledge of the artworks, artists, and cultures you are studying and your ability to interpret them using both assigned readings and materials from class. As part of the discussion, I'll also give you some tips on taking effective notes.

Slide identifications and short-answer questions

Students often find slide identifications to be the most frustrating and difficult part of art-history exams. A slide identification usually consists of a single slide, shown for one to five minutes, which the student must identify according to artist, title, date, medium, and period or culture. For Figure 5.1, a complete slide identification would be:

Frida Kahlo, *The Two Fridas*. 1939. Oil on canvas. Mexico.

In addition to the basic identification, an accompanying

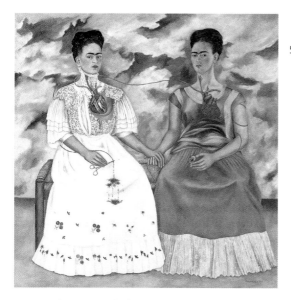

5.1 Frida Kahlo, *The Two Fridas*, 1939. Oil on canvas. Museo de Arte Moderno, Mexico City.

question may ask about a specific issue or interpretation in relation to the piece, or your instructor may simply ask you to comment generally on its significance. This slide could be accompanied by the question:

Why are there two women depicted here?

And a good short answer would be:

This is a double self-portrait, for Kahlo represents two sides of herself. One self-image wears an elaborate white dress (perhaps a wedding dress), while the other wears a simple Mexican costume. The emblems held by the two figures, a surgical tool and a portrait of her husband, Diego Rivera, refer to two core experiences in her life, a terrible accident and her marriage. The arteries linking the two figures, and their clasped hands, show how these various elements come together to shape Kahlo's identity.

Why are slide identifications important?

Are art-history instructors sadists, or is there a purpose to slide identifications? The night before an exam students may harbor dark suspicions about their instructors, but slide identifications can be an important part of training in art history. Preparing for slide

identifications both teaches the basic material of art history and trains visual memory.

If you are going to achieve even a beginner's level of mastery in an academic discipline, you must learn the material of that discipline. In art history, you need to be able to recall images visually, from memory, to help you understand works of art as you are exposed to them. For example, if your instructor discusses how Paul Gauguin (1848–1903) modeled some of his compositions on Egyptian sculpture, you want to be able to remember what Egyptian sculpture looks like in order to appreciate Gauguin's work more fully. Like the analytical and interpretive abilities you acquire through the study of art, a well-trained visual memory will enrich your life and enhance your appreciation of art in a variety of settings, even if you don't become an art historian.

Why are slide identifications so hard?

I think one of the main reasons that students find slide identifications so frustrating is that they tend to seem like a thousand unconnected little bits of information to be memorized individually. Most of us don't have well-trained memories; memorization is out of fashion, so we don't learn poems and essays by heart in elementary school the way children did fifty years ago.

It's especially hard to train visual memory, the ability to recognize and recall works of art. The habits of "lazy looking" developed in response to the barrage of visual images that we see everyday—via TV, magazines and newspapers, the web, billboards, advertisements—mean that we rarely take time to examine visual images carefully, but instead analyze them quickly and superficially. Since most of the images we see are throwaways, it's hard to get out of the habit of mentally discarding most of what we see, including what's presented in the textbook or in the classroom. This means that, as you learn the materials and methods of art history, you also have to learn memorization techniques that actually reduce and make easier the amount of material to be memorized.

How to succeed at slide identifications

There are two essential techniques in preparing for slide identifications:

- Don't leave your studying to the night before.
- Make connections between images and group them in sets.

The first point may seem ridiculously obvious—and I'm sure you've heard it before—but it can't be emphasized enough in art history. Cramming for an art-history exam is like trying to run a marathon without doing any training until the day before. You can't cram images, unless you are lucky enough to have a perfect photographic memory. The night before an exam you'll need to refresh your memory (I always had to work on dates), go over your weak points, and review major issues and images. But you must be "in training," working on images, all the time. Schedule periodic reviews for yourself throughout the semester (at the end of each week, or at the end of each section) to stay on top of the material.

The second point is just as important. Rather than having all these free-floating bits of information buzzing around in your head, you want to anchor them by making connections between images. You must create a context for the images, so that they make sense to you. Usually the class lecture or the text isn't enough to do that alone, which is why you need to spend time studying images, and studying them in different ways. For example, if you're studying Impressionist art, you should review the images repeatedly, but in groups organized according to different principles. For example, you might create groups according to:

- Artist: Manet, Cassatt, Rodin, Eakins, Whistler
- Location: Paris, London, United States
- Date: circa 1860, circa 1870, circa 1880
- Medium: painting, drawing, sculpture, architecture, printmaking
- Subject matter: portraits, family life, spirituality, the city, the country landscape

In this way, you'll connect each image to a variety of other

images in different ways. They will start to form patterns, and these patterns are easier to remember than individual images or bits of information about them.

Three-step slide memorization

Here's an effective, three-step method for memorizing images:

- ▶ Prioritize
- ▶ Familiarize
- ▶ Contextualize

Prioritize. If you feel overwhelmed by the number of slides your instructor has asked you to memorize, prioritize them. Look for the works of art that were discussed at length in class and/or in your textbook. Look for works of art that reappear again and again in class as comparisons for new works. These are the images most likely to show up in an examination. Prioritizing is especially important if your instructor doesn't pre-select a list of required images (prioritizing is part of the learning process in this situation). Of course, if your instructor hands out a carefully selected list containing just a small number of the images available from class or the textbook, there will be less prioritizing for you to do. In that case, it's best to learn all the images well.

Familiarize. There are several ways to review images for examinations. The major art history survey textbooks all include CDs with images and sometimes other material for review. Many instructors now create websites specifically for their classes that include required images. Others ask students to use the illustrations in their textbooks for review. Some instructors still put the required slides in carousels on library reserve, as they did when I was a student. It's a good idea to check early in the semester how images will be made available to students. In whatever form they're available, you can take the same steps to familiarize yourself with the images.

Work with small groups of images at a time (use the grouping techniques described above to create these

subsets) and study each image individually. First, just look at the image and see what you can recall about it (be sure to cover up the identification if it's visible). You may want to write down the information as you recall it, or just repeat it mentally to yourself. Don't worry if you draw a complete blank at the beginning. When you've remembered what you can, look at the identification, note what you missed, and think about it in relation to the image. Try to explain to yourself why each element of the identification makes sense both historically and in the context of your class discussions and assigned readings. This sort of thinking process is an important step toward contextualizing the images (see below). A good "reverse" way to test yourself is to look at the written identification, and see if you can mentally recall the image. As you learn an image, take it out of the study group so that you're going over a smaller and smaller set of images until you're done.

Contextualize. You need to have as firm a grasp of historical context to do well on slide questions as you do to do well on essay questions. The historical context will generate the groupings you will use for review, as in the Impressionism example above, and it ties together the images so that they make meaningful patterns for you.

Art-history textbooks usually do a good job of providing the historical information you need to know. One of the worst mistakes students make in reading their texts is skipping over this historical information as "filler" and reading only the parts that directly pertain to the images. If you've never studied a culture or time period at all, you may also want to have a look at a basic history book for the region, or a specialized art-history book about the period or culture to get additional background and a better feel for the material. Even an hour spent browsing a specialized book in the library can make a big difference in how comfortable you feel with new and unfamiliar material.

Learning historical context will enrich your understanding of the works of art and give you necessary information for interpreting them in essays and in class

discussion. It will also save you from making unnecessary mistakes in slide identifications. A student taking one of my final exams once identified the Dome of the Rock correctly as an Islamic shrine, but gave the date as 200 AD. Now, if you know that Muslims follow the teachings of the prophet Muhammad, and that Muhammad lived in the sixth to seventh century AD (circa 570–632), you know that a Muslim shrine can potentially date to any time during Muhammad's adult life or later, but it can't date to 200 AD. Even if you haven't got any idea of the exact date of the Dome of the Rock, you can make a reasonable guess, and maybe even get partial credit, if you place it within the timeframe of Islamic history.

By the time you work your way through these three steps you should have a good grasp of all the images. If you are weak on a few, then that will be readily apparent and you can focus on them specifically.

Memory aids

You won't need all the following memory aids, but try them out to see which ones work best for you.

Flashcards. You will usually be able to use the CD-ROM of images included with your textbook as a set of electronic flashcards by arranging the images to appear without identification. If you are really having trouble connecting artists, images, dates, and cultures, then it may be worthwhile to make a set of flashcards that you can carry anywhere and review. Here's how I recommend that my students do it. On one side of an index card, paste or tape a photocopy of a required image (don't start cutting up your textbook!). On the other side, write the elements of the identification that your instructor wants you to know, such as artist, title, date, medium, and period/culture. Include the figure number from the textbook for reference. Some students include a sentence or two on the work's significance. Flashcards take time, but they are worth it, because the learning process occurs both while you're making the cards and in using the finished cards. Plus, if you make them up each week for the images from your reading and class they don't seem like

such a burden. I've had students whose exams improved by two full letter grades after they made flashcards.

Maps. Art-history textbooks usually include maps in each chapter. Use them! They will help you learn historical context and make sense of things. For example, if you're studying the arts of Buddhism, it helps to be familiar with the route of the Silk Road, so you can see how Buddhism and Buddhist images spread from the Indian subcontinent across Asia. You might be less tempted to misidentify a seated Buddha from the Silk Road caves as a Hindu god, as one of my students did.

Cluster dating and timelines. Dates are especially hard to memorize. If you don't know something of the history of the period or culture the artwork comes from, everything may seem very arbitrary to you. A technique I often recommend to my students is "cluster dating." This means that you can cluster works of art around the same date, such as circa 2000 BCE, or circa 1510. This not only reduces the sheer number of dates you have to memorize, but also helps you group the works and think relationally.

However, before you try this technique, ask your instructor about it. Most instructors accept an approximate date for slide identifications. Within five or ten years on either side of the actual date is usually OK, and the increment may be larger for archaeological dates. Check to see what parameters are acceptable in your class before you start developing cluster dating.

CE	100	200	300	400	500	600
Mexico						
	Cylindrical vessel				Temple of Feathered Serpent	
				Teotihuacan		Vessel, Mayan
Andes						
	Paracas Mantle			Moche Earspools		
North America						
	Beaver platform pipe					
	Hopewell culture					

It may also help you to make a simple timeline (artist, title, textbook figure number) in which you plot the major works of art you're studying. The textbooks include timelines that will serve as a helpful guide. Study those timelines, but again, like the flashcards, part of the learning process occurs in the making of the timeline, so be sure to create your own, too. This memory aid is especially helpful for cultures or periods that you haven't

Test-taking strategies for art-history exams

Think before you write

During exams, I see a lot of students plunge into writing as soon as an image flashes on the screen. This is not a good idea. Although students are understandably anxious about having a limited amount of time to write, in reality it's usually enough. Give yourself time to think and be sure of your answer. If you're nervous, it's easy to make a mistake at first glance.

Read the question carefully

Be sure you understand what the question asks. Also, be sure you're answering the question. This may sound silly, but many students will just give a very general analysis of the images or basically answer a different question, the one they wish the instructor had asked. Underline and number the key parts of the question so that you're prepared to cover all the important points.

Outline before you write

It's very important to outline your answer to an essay question before you begin to write. For a thirty-minute essay, I recommend spending a full ten minutes outlining your

answer. This will help you organize your thoughts and answer the question as completely as possible. Instructors are looking for a cogent and focused answer to the question, not for a huge volume of writing. Remember to keep consulting your outline as you write to make sure that you don't forget important points.

Keep looking at the slides

In either slide identification/short answer or essay questions, keep pausing to look at the visual images to make sure you're on the right track. As you write and are immersed in the question, looking at the slide may prompt some additional thoughts and help you check what you've done.

Be specific

Discuss key visual elements of the images in detail to support your interpretation. Be specific in your references to cultural events. Be specific, too, in your references to readings. Demonstrate that you understand the ideas and information offered by the readings and can use them to build an insightful interpretation. Identify the author and title of the work (you usually

studied before. For pre-Columbian art, for example, part of your timeline might look like the one on page 121.

Mnemonics. These are the little tricks for learning images and their identifications by connecting the two by some means that isn't entirely obvious, such as a rhyme or word play. With mnemonics, the weird connection sticks in your mind more easily than the actual information does. For example, a mnemonic might help you "see" the

don't have to worry about listing the date and publisher), so that the instructor can recognize your source.

Be clear and concise

Focus on answering the question and don't provide a lot of extra background material that doesn't directly pertain to the subject at hand. A five-paragraph essay format (introduction—three body paragraphs presenting three main supporting points—conclusion) is often effective. State your basic idea, or thesis, in your introductory paragraph. Have a clear topic sentence for each of the paragraphs in the body of your essay (this is easy to do if you outlined your answer first). Use the conclusion to summarize or extend your arguments.

Don't worry too much about your writing style, but do try to write straightforward sentences. It can help to underline a few key terms or sentences in your answer, to help your instructor find your main points easily—remember, she's grading a lot of exams, and you want to make her job as easy as possible.

Do what you can to get partial credit, if it's offered

I've had many students who didn't put anything down on paper for a slide identification because they didn't know one

part of it, like the date, even though they knew all the other parts. Be sure to write down as much as you know, even if you don't know all of the elements of the identification. The same holds true for essay questions. If you can't answer the whole question, do the parts that you can as thoroughly as possible.

Manage your time

Allot a certain amount of time for each question, and, when it's done, move on. If you have extra time at the end, you can always go back and expand your answers (leave extra space in your exam booklet).

Stay calm!

Students sometimes get so tense about the process of memorizing slides and taking slide tests that they freeze during the exam. There are lots of different strategies for staying calm during testing, including deep breathing, stretching, or taking a minute's break between questions. Stay in the moment: focus on the question you're answering, not the one you just finished or the one that's coming up next. If you need extra help, most colleges and universities have study centers where you can find tips on effective studying and test-taking and get help with test anxiety.

date in the image—if there were eight apples in a still life painted by Paul Cézanne (1839–1906) in 1888, for example.

This is the sort of thing that often forms part of the "folklore" associated with popular classes like the introductory art-history survey, so you may hear something helpful from another student. Remember, though, that different mnemonics work for different people. Don't spend a lot of time trying to develop mnemonics, but if they occur to you as you work with the images, go ahead and use them.

Unknowns

In an "unknown," a work of art that hasn't been discussed in either the class or the text is put on the screen, and students have to identify the artist or period or culture. The best preparation is to know your required images well, because this will teach you the most about individual or cultural styles. In addition, try to isolate the distinctive aspects of the artistic style of each artist or culture you've studied. You may want to pay attention to the artist or culture's use of materials, color combinations, ways of depicting the human figure, gestures, compositions, or kinds of subject matter. Make lists of these distinctive traits for each artist or culture. For example, when I took the art-history survey as an undergraduate, I was able to recognize paintings by Nicolas Poussin (1594–1665) because he used a very distinctive combination of red, yellow, blue, and green in drapery and what I thought of as "frozen" gestures, inspired by figures on Roman sarcophagi. If you're really feeling eager (or anxious), you can also make photocopies of unknown works by artists or cultures that are required and use these like flashcards to test your ability to recognize authorship.

In the exam, when confronted with an unknown slide that you don't recognize, it sometimes helps to eliminate those artists or cultures you know it can't be, for whatever reason. Try to narrow it down to two or three artists or cultures, then think about your list of distinctive traits for each and see which one fits best.

Art-history essays

Art-history examinations often include essay questions because they provide a more in-depth way to test your

interpretive ability and knowledge of the larger themes and issues addressed in the class.

Studying for essay tests

The best way to prepare for essay questions is, obviously, to attend class consistently and complete all the readings. This gives you a good sense of the themes and issues that are fundamental to the course. Pay attention to images that reappear often; themes or issues that are discussed repeatedly; and readings that are a frequent point of reference.

If your instructor provides sample questions or a list of themes and issues, that's clearly the place to start studying. One of my students, when she has the questions ahead of time, goes through her notes and codes them for the different questions. This simultaneously helps her overall review process and pulls together the material she needs to outline her essays. If you don't have questions in advance, go over your class notes and readings and put together a list of themes and issues, and then make up your own exam questions. Put yourself in the position of the instructor: if you were teaching this course, what would you identify as the most important issues to test? After you make up your questions, try answering them.

Preparing for essays is a good time to work with other students in the class (personally, I always found group study less helpful for memorizing slides). Have everyone bring sample questions that they've made up to the meeting, or brainstorm themes and issues and make up questions together.

Essay questions often ask you to identify the slides as a starting point, just as you would in a slide identification, so the slide memorization that you do for identifications will help you here too. Also, the groupings that you create as you memorize slides may give you some ideas for essay questions.

Types of essay question

Thematic essays. This kind of question asks you to interpret images in relation to a basic theme or issue. There are several possible formats for these questions. You may be able to

select your own images in relation to a theme; the images may be specified for you; or you may select them from a list provided. You may have slides of the images shown in the test, or you may have to work from memory without visual aids.

Here's a sample thematic essay question, one that I gave on a final exam for the first half of the art-history survey:

> Images of rulers often seek to connect the ruler with a god or to present the ruler as a deity. Discuss why this is so and analyze how it is accomplished in three works of art, each from a different culture we have studied.

This was an open question in which students could pick their own images, and that of course is the first challenge. It's important to choose works of art that both meet the criteria specified (images of rulers from three different cultures) and also give you an opportunity to develop a strong interpretation. In answering this question, a few of my students chose inappropriate images, such as the sculptures from the Parthenon pediments, which don't depict rulers at all. Others chose two or three works from the same culture, which again doesn't meet the specified criteria. Others picked images of rulers for which the issue of relationship with the gods or an aura of divinity isn't central. One student, for example, picked the Egyptian statue of Menkaure and Khamerernebty (Figure 5.2). There is a case to be made that in their perfect proportions they were presented as godlike, and the statue was intended as a home for their ka spirits, but this is a fairly weak argument compared to those offered by some other images. In an exam situation, you want to pick images that give you a lot to talk about, images you can use to build a strong interpretation—not ones that are a stretch. Here's a good set of images that several

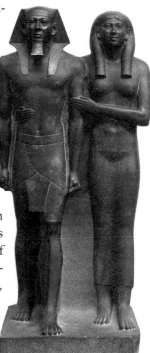

5.2 Menkaure and Khamerernebty, c. 2500 BCE. Slate. Egypt. Museum of Fine Arts, Boston.

students chose for that essay question:

- ▶ Stela of Hammurabi, c. 1792–1750 BCE, basalt, Babylon (Figure 5.3)
- ▶ Akhenaten and his Family, c. 1348–1336 BCE, painted limestone relief, Egypt (Figure 5.4)
- ▶ Colossal Statue of Constantine the Great, 325–6 CE, marble, Roman (Figure 5.5).

A strong, clear introductory paragraph is the essential starting point for any exam essay. The example below starts out with some general observations about images of politicians today, to give the reader (and the writer!) a way to identify with the issues at hand. It then shifts the focus of attention to the ancient world, and, specifically, a thesis statement about the reasons why images of rulers were linked with gods or the divine. The paragraph concludes with a simple, straightforward list of the three images to be discussed in the essay. If there were an appropriate reading to use in writing the essay (there wasn't in this case), that would be included here, too.

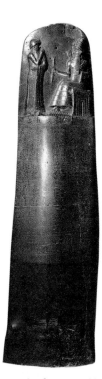

5.3 Stela of Hammurabi, c. 1792–1750 BCE. Basalt. Susa, Iran. Musée du Louvre, Paris.

In developing an interpretation of this work, be sure to consider the relationship between text and image.

> In this day and age, we see numerous images of politicians every day in newspapers, television, and magazines. However, before the advent of mass media, images of rulers were not so common. In the ancient world, when images of rulers appeared—on coins, statues, or wall murals—they were the kind of images that stayed in the community for a long time and that had to be crafted to express carefully selected messages about the ruler in question. One way to create impressive images and reinforce the ruler's power was to link the ruler with the gods or to make the ruler appear divine in some way. This conveyed the idea that the ruler had innate authority, and perhaps even a "right" to rule. Three such images are the Stela of Hammurabi (Shumash), the Akhenaten relief, and the colossal statue of Constantine.

The body of the essay then consists of three paragraphs, each focusing primarily on one of the images. Note how the contextual interpretation of the images depends on close visual analysis in these first two paragraphs:

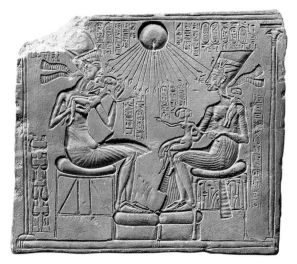

5.4 Akhenaten and his Family, 1348–1336 BCE. Painted limestone relief. Staatliche Museen zu Berlin, Preussischer Kulturbesitz, Ägyptisches Museum.

In any interpretation of this work, you would want to address the dramatically different artistic style used to depict Akhenaten compared to other Egyptian rulers.

In the Stela of Hammurabi, the ruler Hammurabi appears with Shumash, a powerful god. To convey a sense of his superhuman power, Shumash is seated on a throne and if he stood up he would be much taller than Hammurabi. He holds a hoop and rods, which represented justice and power in ancient Babylon. To show his respect for the god, Hammurabi remains standing and holds his hand to his mouth. So even though Hammurabi is in this sense inferior to the god, at the same time the two of them do appear close together, as if they cooperate or as if Hammurabi, though inferior, shares in the god's power. The Stela also lists the laws known as the Code of Hammurabi, and the image of Hammurabi with Shumash may even suggest that the laws came from the god, or were approved by him.

The Akhenaten relief also shows Akhenaten receiving divine approval in ways that are both similar to and different from the Stela of Hammurabi. Akhenaten is seated with his wife and two daughters and they seem to be sharing an intimate family moment, but this is no ordinary family. Akhenaten claimed descent from the sun god Aten and introduced his worship as a way of challenging the power of the Theban priests. The appearance of the sun at the top of the relief actually represents the god, so Akhenaten, like Hammurabi, appears close together with the god. The rays of the sun have small hands at their ends, which hold the

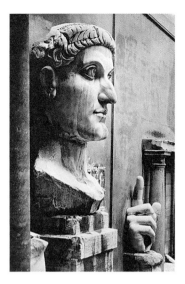

5.5 Colossal statue of Constantine the Great, 325–6 CE. Marble. Palazzo dei Conservatori, Rome.

Because this statue exists in a fragmentary condition, viewers today must mentally recreate its original appearance.

ankh, the symbol of life, to the noses of the family members (literally "the breath of life"). However, the relief does not include anything as specific as a law code, so it conveys a more general sense of the god's favor toward Akhenaten and his family, rather than his favor toward a specific policy or agenda, like the Stela of Hammurabi. Although Hammurabi appears strong and vigorous, and like an idealized image of a king rather than a specific personal portrait, Akhenaten is shown with his distinctive long face and potbelly stomach. This may suggest the importance of divine truth (*maat*)—so the pharaoh may appear less than perfect here—but he is also shown communing with the sun god Aten, a connection that then also takes on the aura of *maat*.

Although the second paragraph focuses primarily on the Akhenaten relief, it also makes explicit comparisons between the stela and the relief. The writer discusses the images in chronological order, which is simple and straightforward. The chronological order leaves the statue of Constantine to be discussed last, which isn't a bad idea because the statue raises some distinctly different issues in comparison with the other two pieces.

Unlike the other two pieces, which are relief sculptures, the colossal statue of Constantine was a freestanding sculpture.

It was made for the Basilica of Maxentius and Constantine, which was a government center (not a temple or church as we think of basilicas today). Because Constantine spent most of his time in his new capital, Constantinople, where he governed the eastern part of the empire, the colossal statue "stood in" for him when he was not in Rome. In the ancient world, there was a tradition of making colossal statues of gods and goddesses, like the statue of Athena in the Parthenon. So instead of the other two pieces, which link the ruler to a specific god, this enormous portrait makes Constantine *like* a god. The statue could stand in for him and watch over the government, just as the statue of Athena could stand in for her and watch over temple rituals. Like the Akhenaten relief, and unlike the Stela of Hammurabi, it conveys a general sense of Constantine's divine authority, and is not linked to a particular policy.

If you have time, it's a good idea to write a concluding paragraph for your essay, but in general I would advise against rushing through the body of the essay just to squeeze one in. The conclusion gives you a chance to summarize your argument and present any final thoughts on the subject. For this particular essay question, students who wrote conclusions did different things with them. One student pointed out in the conclusion that each one of these rulers was doing something new or revolutionary (Hammurabi with his law code, Akhenaten with his new religion, and Constantine with his new capital city) and each depicted his connection with the gods to help validate these actions. Another student used the conclusion briefly to compare the images of rulers she had discussed in her essay with the portrayal of American presidents today. This was a surprising but effective tactic. Her comments suggested to me that she was thinking broadly about the topic, and taking what she learned in the class and applying it to the world around her.

Responding to a quotation or statement. This type of essay usually takes one of the course readings as its starting point. It asks you to interpret works of art in terms of a statement by a scholar, artist, or historical figure. Here's

an example of this kind of question:

> The artist Paul Klee once stated, "The work of art is above all a process of creation: it is never experienced as a mere product." Analyze the work of three twentieth-century artists (other than Klee) in terms of this idea.

The introductory paragraph should clearly state your perspective on the quotation and introduce the artists you intend to discuss to support your viewpoint. In this type of question, the introductory paragraph may be longer and address more substantial issues than in other types of essay question. You need to demonstrate that you fully understand the perspective offered by the quotation and are able to respond to it. You may or may not agree with the quotation, but you must develop a strong argument either way. In this case, each of the paragraphs in the body of the essay would address a different artist.

Possible subjects for analysis within this framework include Jackson Pollock (1912–1956), Cy Twombly (b. 1928), and performance artists such as Joseph Beuys (1921–1986), Ann Hamilton (b. 1956), and Karen Finley (b. 1956). Pollock's "action painting," for example, made the canvas "an arena in which to act"; as the art critic Harold Rosenberg once noted, a Pollock canvas became not a picture but an event. Artists such as Duane Hanson (1925–1996) might be less easily included. His eerily lifelike castings of human beings emphasize the effect of the finished piece on the viewer over the process of making it (as painstaking and involved as that process may be). In the conclusion to such an essay, it's a good idea to return to the quotation as a basis for presenting your final thoughts on the subject.

Creative question. This type of thematic question asks you to respond creatively to the themes and issues presented in the course. For example, you might be asked to write a plan for a museum exhibition or a website, or to write an essay in the voice of an eighth-century iconoclast. It's important to remember with this type of question that the focus is still on the material presented in the course. You still need to include detailed visual and contextual

analysis to show that you understand the works and how they might be brought together within the framework of an exhibition or website, for example.

Here's a sample essay question of this type that I wrote when teaching introductory art history as a grad student at Columbia University. The class had made several trips to the Metropolitan Museum of Art and other museums around the city. Students had a list of required images from the museums that they had to study for the exam, in addition to required slide images from class, and I developed a question around one of those museum images (Figure 5.6):

> The Metropolitan Museum of Art has asked you to develop a comparative, cross-cultural exhibition about the role of the artist in society, using Labille-Guiard's *Self-portrait with Two Pupils* as the centerpiece of the exhibit. Write an exhibition proposal explaining the theme of your exhibition and specifying three pieces that you would include in the exhibition in addition to this painting. One of these pieces should be from a museum collection in the city, and two from the images we have studied in class. Explain why you are choosing these pieces, how they relate to the Labille-Guiard self-portrait, and how you would exhibit them.

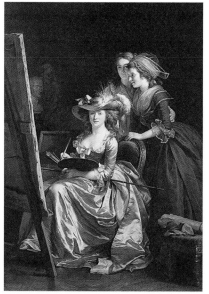

5.6 Adélaïde Labille-Guiard, *Self-portrait with Two Pupils, Mademoiselle Marie Gabrielle Capet and Mademoiselle Carreux de Rosemond*, 1785. Oil on canvas. Metropolitan Museum of Art, New York.

There are many good ways this question could be answered, but I wanted students to demonstrate several things. The bottom line—that they participated in the museum visits and studied the collections. More importantly, that they had thought carefully about the role of the artist, which we had addressed at various points in the course. Finally, and most challenging, that they were able to take this theme and apply it creatively to required images.

Comparisons. A distinctive kind of art-history question is the comparison. In a comparison, two slides are shown and students are asked to compare and contrast the images—to discuss the similarities and differences between them. This kind of question may ask you to discuss two images within a culture or period, or images across cultures or periods. Your instructor may provide a specific question to answer, or you may have to determine yourself the important issues raised by the juxtaposition of the two images. Here's a sample pair:

- ▸ Shrine at Ise, first century CE (rebuilt every twenty years), wood and thatch, Japan (Figure 5.7)
- ▸ Temple of Horyu-ji, seventh century CE, wood and other materials, Japan (Figure 5.8)

Let's approach this pair as if they were shown as a comparison without a question provided. In this situation, it's especially important to spend time thinking and outlining your answer before you begin to write. You want to make sure that you're focusing on the central issue presented by the pairing of the two images. Pairings like this aren't random—usually your instructor is prompting you to discuss an important theme or issue in the course.

This pair addresses the different styles of architecture associated with two different religions in Japan. Each architectural style tells the viewer something distinctive about the values and/or history of the religion. A solid introductory paragraph would state this thesis and identify the two images. The body of the essay should then give an account of each building, its history and

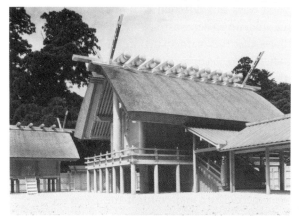

5.7 Shrine at Ise, first century CE (rebuilt every 20 years). Wood and thatch. Mie Prefecture, Japan.

5.8 Temple of Horyu-ji, seventh century CE. Wood and other materials. Nara Prefecture, Japan.

background, and compare and contrast them. Here's the body of a good answer to this question:

The shrine at Ise is associated with Shinto, an indigenous religious tradition in Japan that emphasizes the worship of nature spirits (kami). In keeping with this focus, the building takes the form of a granary and is made of natural materials like unpainted wood and thatch. The shrine is rebuilt every twenty years, evoking the natural cycle of the seasons.

In contrast, the more ornate style of Horyu-ji draws on the traditions of Chinese architecture and represents an imported rather than indigenous style. Horyu-ji uses the bay system of construction, pagoda form, and bracketed eaves of Chinese architecture. Unlike Ise, with its emphasis

on natural materials, the wood and other materials used at Horyu-ji are painted, carved, and otherwise highly finished. This style reflects the cultural origins of the religion practiced there, because Horyu-ji is a Buddhist shrine, and Buddhism was introduced to Japan from China and Korea.

Both of these styles developed in the context of imperial patronage, although they express it in different ways. The shrine at Ise is especially associated with the imperial family, for it houses sacred objects associated with the sun goddess, their ancestress. Despite this, it is a style that emphasizes the simple and natural in keeping with Shinto beliefs. Buddhism had in China enjoyed imperial patronage, and so developed grand style reflecting the wealth of the temples. This style was then imported to Japan and maintained there because members of the Japanese imperial court also patronized Buddhist temples. Horyu-ji itself was founded by Prince Shotoku, who ruled Japan as regent in the seventh century CE. In Japan, these two religions were considered compatible and were practiced at the same time, as were the distinctive architectural styles associated with them.

A mistake a lot of students make in comparisons is simply describing one image and then the other without ever relating the two. Make sure you're discussing the similarities and diuyb erences between them. Words like "similarly", "unlike", "both", "in contrast", and "while" are good clues that you're developing a strong comparative essay. As with a thematic essay, the conclusion should summarize your argument and present any final thoughts.

Effective note-taking

One of the most important things you can do to help yourself do well in art-history exams is to take good notes in class and on the readings. There are some distinctive aspects to art history that can make note-taking difficult. In class it can sometimes seem like there are so many artists' names, place names, dates, and images that it's impossible to write everything down. Afterward, confronted by pages of cryptic scribbles, you may have difficulty sorting it all out or even simply remembering what the images were.

Taking good notes in class

Sometimes instructors will hand out reference sheets of names and dates, write them on the board before class begins, or list them on a website. If not, try to spell out artists' names, place names, and specialized terms as fully as you can the first time you hear them. One of my students brings her textbook to class and glances through the relevant chapter so that the names and spellings are more familiar to her. Another student takes notes just on one side of the notebook page spread, and then, afterward, uses the facing blank page to write out image identifications and note key themes and issues. Whatever your system, it's a good idea to write a new name or term in the margin the first time you hear it—or just put a star or arrow in the margin to signal a new term. Don't worry too much about getting the exact spelling when you're taking notes in class, just try to get close enough and go back later to fill in the absolutely correct spelling from your textbook or the instructor's reference sheets.

One of the most difficult things about art-history classes is seeing images for the first time in class and then trying to identify and remember them later. If you don't catch the full identification of an image the first time, write down as much as you can of the title and the artist or culture. To help yourself identify the work under discussion later, jot down any distinctive visual features of the work—a particularly bright shade of blue used in a painting, a long fringe on a textile, a circle of deer on a metal beaker. Even a simple sketch of the image in the margin of your notebook can help you identify it later. After class, go back and fill in the full title, using information your instructor provided at the start of class or by referring to your textbooks. You may even want to write the figure number from the textbook in the margin for quick reference.

As you can already tell, it's important to go over your notes soon after class, while your memory is still fresh, to fill in missing information and sort out any problems. It's best if you can do it the same day, but if not, try to do

Class participation — why bother?

Instructors threaten, cajole, reward. Students roll their eyes. Why is class participation so important? First, when you're part of the discussion, you'll be more attentive and less likely to zone out. Second, you'll learn more and more quickly, because it's better to be actively engaged rather than passive in the learning process. How do you get over the fear of speaking up in class? Try asking a question, just to get your voice heard. Often it's easier to participate if you sit in the front of the class, especially in a lecture hall. In my class of 150 students, one student who was a great participant said she sat up front so she felt like she was in a class with just twenty people, rather than a big lecture, and that made it easier to speak.

it the same week. You don't want to be confronted by a mass of indecipherable notes the night before an exam.

As a graduate student, I used to type up the notes from my lecture classes so that they would be perfectly clear and safely stored on my computer (and a backup disk), in case I lost my notebook. (I admit that I didn't do this as an undergrad!) That's a lot of effort and may not be worth doing—or possible—for every class. However, if you're having particular trouble with your art-history class or if you want to keep your notes for future reference, then formally writing them up is a good idea.

Developing a consistent shorthand

Use abbreviations and symbols to help you write quickly and accurately in class. If your instructor emphasizes a point in class (by repeating it several times or saying something obvious like "this is really important"), put stars or arrows next to it in the margin of your notes.

Keep a list of these symbols and abbreviations in your notebook, to help you use them all the time—and to remind you of their meaning in case you forget! Some of the ones you are likely to use are standard: "c." for circa, "bcs" for "because", "usu" for "usually", "prob" for "probably." When I was an undergraduate, I found it helpful to develop my own shorthand for proper nouns. I still remember a few of them: "eg" was Egyptian, "mich" was Michelangelo, and "j the b" was John the Baptist.

Taking notes on readings

Lots of students use highlighters or underlining to mark key points in their readings. This is a good technique, but I recommend supplementing it with several others. When you're studying for an exam, it takes a long time to go through an article and find all the highlighted passages —often you end up having to reread the article or chapter to reconstruct the argument.

First, when you're highlighting or underlining, also make notes in the margins of the readings (as long as they're not reserve books!) with cross references to other readings or images, or observations that you find surprising, interesting, convincing, or unconvincing. Second, for important readings, I also recommend writing out a simple summary on a single sheet of paper in addition to highlighting or underlining. Put the author and title at the top of the sheet, and then in one sentence state the author's thesis, or main point. Summarize the key points of the argument in three to five sentences, and note any images that are discussed at length. Staple this sheet to the front of the photocopy, or gather together the summaries in your notebook. It won't take long to do this after you finish each reading, but it will save you a lot of time when you're studying for exams. You can create a template in a word-processing program at the beginning of the semester and print out the number you need so that there's no excuse for not doing it.

Conclusion

The point of this chapter is to try to make test-taking a manageable, productive endeavor. You don't want tests to loom large in your experience of art history, and the techniques I have described should help you cut them down to size. Experiment with the ideas presented here to develop a study system that works for you.

Chapter 6
Art history's own history

> But history, real solemn history, I cannot be interested in . . .
> I read it a little as a duty, but it tells me nothing that does not
> either vex or weary me. The quarrels of popes and kings, with
> wars or pestilences, in every page; the men all so good for
> nothing, and hardly any women at all—it is very tiresome.
>
> Catherine Morland in Northanger Abbey,
> Jane Austen (1775–1817)

Art history has a long history of its own, as a distinct way of analyzing visual images. There are certain key issues in art history that scholars have been thinking about—albeit in various ways—since the Renaissance and even, in some respects, earlier. It may help you develop your skills in art-historical analysis to think about how art history's methods developed and to situate the ideas you work with in their historical context. This chapter presents only a brief survey, so check the bibliography for other works providing more in-depth accounts.

Ancient world

Certain writers of the ancient world practiced forms of interpretation that we can see as related to, or fore-runners of, the modern-day practice of art history. Greek and Roman commentators tried to explain how and why works of art were made; to distinguish between the works of different artists; to record the public reception of works of art and the ongoing significance of works of art; and to account for stylistic change over time. Many artists, such as the Greek sculptor Polykleitos (fl. 460–315 BCE), wrote treatises describing the process of making

art, defining what constitutes ideal art, and discussing examples of artworks that fulfilled these ideals. Unfortunately, most of these texts don't survive.

The Roman statesman and scholar Pliny the Elder (23–79 CE) produced one of the most important ancient

Excerpt from Pliny's *Natural History*

Pliny's *Natural History* comments both on contemporary art practices in Rome and on the history of the arts. Pliny was particularly concerned with how particular media were invented (he attributed the origins of painting, for example, to early people tracing the outlines of shadows) and in telling the history of the careers of famous artists and analyzing their works. This passage (Book 34, Ch. 19) discusses some of the most famous Greek sculptors of the fifth century BCE:

"The ages of the most celebrated artists being thus distinguished, I shall cursorily review the more eminent of them, the greater part being mentioned in a desultory manner. The most celebrated of these artists, though born at different epochs, have joined in a trial of skill in the Amazons which they have respectively made. When these statues were dedicated in the Temple of Diana at Ephesus, it was agreed, in order to ascertain which was the best, that it should be left to the judgement of the artists themselves who were then present: upon which it was evident that that was the best which all the artists agreed in considering as the next best to his own. Accordingly, the first rank was assigned to Polycletus, the second to Phidias, the third to Cresilas, the fourth to Cydon, and the fifth to Phradmon.

Phidias, besides the Olympian Jupiter, which no one has ever equaled, also executed in ivory the erect statue of Minerva, which is in the Parthenon at Athens. He also made in brass, beside the Amazon above mentioned, a Minerva, of such exquisite beauty, that it received its name from its fine proportions. He also made the Cliduchus, and another Minerva, which Paulus Aemilius dedicated at Rome in the Temple of Fortune of the passing day. Also the two statues, draped with the pallium, which Catullus erected in the same temple; and a nude colossal statue. Phidias is deservedly considered to have discovered and developed the toreutic art.

Polycletus of Sicyon, the pupil of Agelades, executed the Diadumenos, the statue of an effeminate youth, and remarkable for having cost one hundred talents; as also the statue of a youth full of manly vigour, and called the Doryphoros. He also made what the artists have called the Model statue, and from which, as from a sort of standard, they study the lineaments; so that he, of all men, is thought in one work of art to have exhausted all the resources of art . . . Polycletus is generally considered as having attained the highest excellence in statuary, and as having perfected the toreutic art, which Phidias invented. A discovery which was entirely his own, was the art of placing statues on one leg. It is remarked, however, by Varro, that his statues are all square-built, and made very much after the same model. "

texts about art. His encyclopedic *Natural History*, a thirty-seven-volume work, "set forth in detail all the contents of the entire world." Pliny outlined a broad scheme of artistic development according to a model of birth–development–decline (for him, the apex of art was achieved in fifth- and fourth-century BCE Greece). Within this framework, he discussed numerous individual artists and works of art, setting them in historical context and judging their artistic value.

The early Christian theologian Saint Augustine (354–430 CE) drew on his classical training as a philosopher to develop a distinctive and influential understanding of religious images. The Platonic tradition of aesthetics guided his exploration of the qualities of beauty; for him, beauty was intrinsic and not "in the eye of the beholder." Further, beauty derived from God: "for all those beautiful things that here are conveyed through the souls into the artful hands come from that Beauty that is above the souls and for which my soul sighs day and night." Not surprisingly, Augustine was sensitive to the role that visual images played in worship, noting that the viewer "reads" a picture just as one reads a book. This understanding of the role of images became increasingly important—and contested—in the Middle Ages.

Middle Ages

The Middle Ages in Europe was a time not only of tremendous artistic productivity but also of great debates about the arts. There are relatively few biographies or accounts of particular artists from this period, reflecting the status of the painter or sculptor as craftworker rather than artistic genius. Much religious writing about art from this time doesn't address historical issues, but instead theorizes about what art should do, particularly in fostering spirituality. Strangely enough, it was an effort by some Church officials in the eighth and ninth centuries to destroy works of art, which they saw negatively as promoting idolatry, that actually prompted some of the most revealing medieval commentaries on the nature and meaning of art. Somewhat later, Abbot Suger

(c. 1081–1151), who renovated the French royal monastery at Saint-Denis in the new Gothic style, produced several unique texts that, in justifying the enlargement and embellishment of the monastery, developed a theory of art. Thomas Aquinas (1225–1274) asserted that images in churches are necessary because they instruct "simple people" who can't read; they keep religious ideas in people's minds by putting them constantly before their eyes; and they stimulate feelings of devotion.

Two types of writing from ancient times, *ekphrasis* and guidebooks, continued to be important forums for writing about art during the Middle Ages. *Ekphrasis* is a type of rhetoric that presents vivid descriptions of works of art, either real or imaginary. In 563 CE, for example, Paulos Silentiarios composed a poetic *ekphrasis* praising Hagia Sophia in Constantinople to celebrate the rebuilding of the dome by the emperor Justinian (ruled 527–565). His description provides useful information about the building not found elsewhere. With the rise of pilgrimage in the Middle Ages, guidebooks continued to be popular. Many focused on the Holy Land and Rome, the two primary pilgrimage destinations. Although their authors were not systematically and self-consciously writing art criticism or art history, guidebooks often provide extensive commentaries about art and architecture in their descriptions of local points of interest.

Renaissance

With a renewed interest in the Classical past and a keen appreciation for artistic genius, Renaissance authors wrote extensively about the history, philosophy, and practice of art. Perhaps the most famous of these writers was Giorgio Vasari (1511–1574), who is sometimes called "the founder of art history." Vasari was a student of Michelangelo, a gifted painter and architect in his own right, and an active art collector. Vasari's primary importance to art history rests on another of his achievements, *The Lives of the Artists*, a history of Italian art that was first published in 1550 and issued in a revised and expanded edition in 1568. In this work, Vasari aimed to reinforce

the transformation of the artist from artisan to inspired genius, celebrate patrons of the arts as people who promote the advance of civilization, and ensure the excellence of future art by reminding artists of the core values that should inspire them.

Like Pliny, Vasari saw the arts repeating a cyclical model of birth – development – decline. Accordingly, Vasari's *Lives* consists of three parts. The first outlines the history of art from earliest antiquity to Cimabue (c. 1240–1302) and Giotto di Bondone (c. 1267–1337), the first artists of the Renaissance. The second part discusses art of the fifteenth century, including Masaccio (1401–c. 1428), Piero della Francesca (c. 1420–1492), and Andrea Mantegna (1431–1506). The third presents those artists whom Vasari considered to be the greatest artists of the Renaissance: Leonardo da Vinci (1452–1519), Raphael (1483–1520), and Michelangelo. As Vasari's own teacher and primary inspiration, Michelangelo (not surprisingly) appears in this work as the greatest artist of all time.

Vasari's biographical framework allowed him to discuss issues that would appeal to the various members of his audience, which included the artists themselves, patrons, and connoisseurs. He was concerned with many questions that continue to interest art historians, including patronage, the development of individual and period style, the analysis of an artist's sources and inspirations, and the history of the creation and reception of specific works of art. Some of Vasari's methods are still at the core of art-historical practice today: the use of textual evidence, the close examination of works of art, and the study of drawings as a key to the creative process (Figure 6.1).

Vasari had many imitators. Karel van Mander (1548–1606), a Dutch painter, wrote *The Painter's Book* between 1583 and 1604. He applied Vasari's model to northern European art, only instead of measuring this art against antiquity, as Vasari had done, he used contemporary Italian art as his standard. A little more than a hundred years after Vasari first published his *Lives*, the antiquarian Giovanni Pietro Bellori (1615–1696) wrote, with the help

Excerpt from Vasari's *Lives of the Artists*

This passage mixes extravagant praise of Raphael's person and art with gossipy anecdotes and some insightful and informative analysis of his work:

" With wonderful indulgence and generosity heaven sometimes showers upon a single person from its rich and inexhaustible treasures all the favours and precious gifts that are usually shared, over the years, among a great many people. This was clearly the case with Raphael Sanzio of Urbino, an artist as talented as he was gracious, who was endowed by nature with the goodness and modesty to be found in all those exceptional men whose gentle humanity is enhanced by an affable and pleasing manner, expressing itself in courteous behaviour at all times and towards all persons.

Nature sent Raphael into the world after it had been vanquished by the art of Michelangelo and was ready, through Raphael, to be vanquished by character as well. Indeed, until Raphael most artists had in their temperament a touch of uncouthness and even madness that made them outlandish and eccentric; the dark shadows of vice were often more evident in their lives than the shining light of the virtues that can make men immortal. So nature had every reason to display in Raphael, in contrast, the finest qualities of mind accompanied by such grace, industry, looks, modesty, and excellence of character as would offset every defect, no matter how serious, and any vice, no matter how ugly. One can claim without fear of contradiction that artists as outstandingly gifted as Raphael are not simply men but, if it be allowed to say so, mortal gods, and that those who leave on earth an honoured name in the annals of fame may also hope to enjoy in heaven a just reward for their work and talent . . .

And at that time, when his reputation was very high indeed, Raphael did an oil-painting of Pope Julius. This portrait was so true and lifelike that everyone who saw it trembled as if the Pope were standing there in person. Today it is in Santa Maria del Popolo, together with a very beautiful painting of Our Lady executed at the same time, which shows the Birth of Jesus Christ with the Virgin laying a veil over her son. The attitude of the child's head and every part of his body are so beautiful that he is clearly the true son of God; and no less fine are the head and face of the Madonna whose serene beauty wonderfully expresses her piety and joy. St Joseph is shown, his hands resting on a staff, contemplating the king and queen of Heaven with the devout wonder of a holy old man. Both these works are exhibited on important feast days.

By now Raphael had made a great name for himself in Rome. He had developed a smooth and graceful style that everyone admired, he had seen any number of antiquities in that city, and he studied continuously; none the less, his figures still lacked the indefinable grandeur and majesty that he now started to give them.

What happened was that Michelangelo at that

time made his terrifying outburst against the Pope in the Sistine Chapel (as I shall describe in his Life) and was forced to run away to Florence. So then Bramante, who had the keys of the chapel, being a friend of Raphael, brought him to see Michelangelo's work and study his technique . . . and what he had seen of Michelangelo's paintings enabled him to give his own style more majesty and grandeur, so that he improved the picture out of all recognition. When Michelangelo saw Raphael's work later on he was convinced, and rightly, that Bramante had deliberately done him that wrong for the sake of Raphael's reputation and benefit. **"**

(Penguin edition, pp. 284, 297–8)

6.1 Page from Giorgio Vasari's *Libro de' disegni: Allegorical Scene*, attributed by Vasari to Vittore Carpaccio (c. 1465–c. 1525). British Museum, London.

Vasari's **Libro de' disegni** (Book of Drawings) *comprised eight volumes of drawings by different artists. Intended as a companion to his* Lives of the Artists, *the Libro de' disegni also included both great and lesser artists to provide a complete account of Italian art. On each page, Vasari mounted one or more drawings by a particular artist and then drew an elaborate architectural border around them. Vasari attributed this drawing to the Venetian painter Vittore Carpaccio, although scholars now believe that it was executed by a follower of the Umbrian painter Luca Signorelli (c. 1441–1523).*

of the painter Nicolas Poussin, a book titled *Lives of the Modern Painters, Sculptors and Architects* (1672). Bellori's work differs from Vasari's *Lives* in that Bellori included only the artists that he considered to be the best, whereas Vasari sought to document Italian art more broadly, including lesser artists, to convey a full picture.

Age of Enlightenment

During the eighteenth century, writers on art began to move away from Vasari's model to create new interpretive frameworks for thinking about art. The rise of modern

6.2 Hagesandrus, Polydorus, and Athenodorus, *Laocoön and His Two Sons*, first century CE. Marble. Vatican Museums, Rome.

Winckelmann on the Laocoön

Winckelmann's *Reflections on the Imitation of Greek Works in Painting and Sculpture* (1755) defines the essence of Greek art and then discusses how and why artists through time have been drawn to this tradition. Some of the most famous passages from this work concern the Hellenistic statue of Laocoön, unearthed in Rome during the Renaissance (Figure 6.2):

" The only way for us to become great or, if this be possible, inimitable, is to imitate the ancients. What someone once said of Homer—that to understand him well means to admire him—is also true for the artworks of the ancients, especially the Greeks. One must become as familiar with them as with a friend in order to find their statue of Laocoön just as inimitable as Homer. In such close acquaintance one learns to judge as Nicomachus judged Zeuxis' Helena: 'Behold her with my eyes,' he said to an ignorant person who found fault with this work of art, 'and she will appear a goddess to you' . . .

Laocoön was for the artist of old Rome just what he is for us—the demonstration of Polyclitus' rules, the perfect rules of art . . .

. . . The most beautiful body of one of us would probably no more resemble the most beautiful Greek body than Iphicles resembled his brother, Hercules. The first development of the Greeks was influenced by a mild and clear sky; but the practice of physical exercises from an early age gave this development its noble forms . . .

The general and most distinctive characteristics of the Greek masterpieces are, finally, a noble simplicity and quiet grandeur, both in posture and expression. Just as the depths of the sea always remain calm however much the surface may rage, so does the expression of the figures of the Greeks reveal a great and composed soul even in the midst of passion.

Such a soul is reflected in the face of Laocoön —and not in the face alone—despite his violent suffering. The pain is revealed in all the muscles and sinews of his body, and we ourselves can almost feel it as we observe the painful contraction of the abdomen alone without regarding the face and other parts of the body. This pain, however, expresses itself with no sign of rage in his face or in his entire bearing. He emits no terrible screams such as Virgil's Laocoön, for the opening of his mouth does not permit it; it is rather an anxious and troubled sighing as described by Sadoleto. The physical pain and the nobility of soul are distributed with equal strength over the entire body and are, as it were, held in balance with one another. Laocoön suffers, but he suffers like Sophocles' Philoctetes; his pain touches our very souls, but we wish that we could bear misery like this great man.

The expression of such nobility of soul goes far beyond the depiction of beautiful nature. The artist had to feel the strength of this spirit in himself and then impart it to his marble. Greece had artists who were at once philosophers, and there was more than one Metrodorus . . . "

universities in Europe meant that the history of art, instead of being the province only of artists and connoisseurs, took its place among the established academic disciplines, including philosophy, history, and archaeology.

Chief among these new scholars of art history was a German named Johann Joachim Winckelmann (1717–1768). Winckelmann studied theology and medicine at university, but became interested in Greek art when working as a librarian in Dresden and eventually moved to Rome. In his writings, he encouraged scholars to study the monuments directly and look at works of art with an artist's eye to recapture the creative spirit. Winckelmann moved away from Vasari's biographical model in directly addressing cultural context. He explored how factors such as climate, government, habits of thought, the status of the artist, the use of the work of art, and scientific knowledge contribute to the rise and development of a particular artistic style. At the same time, he maintained Vasari's cyclical model of birth–development–decline to chart the history of art.

The great German philosopher Immanuel Kant (1724–1804) also made important contributions to the study of art in the eighteenth century. In his *Critique of Judgement*, Kant explored an issue central to art history: how we make judgements or distinctions between things. He argued that judging works of art is equivalent to judging nature; in both cases we make judgements in terms of beauty, whether natural or artistic. Aesthetic response occurs when two mental faculties, imagination and understanding, are specially activated. Kant's view that the aesthetic response to beauty really concerns form and design alone (as opposed to history or context) was very influential. His ideas contributed to the development of formalist perspectives on the significance and value of works of art.

Johann Wolfgang von Goethe (1749–1832) was a poet, historian, statesman, scientist, and prolific commentator on the arts. Today, art historians consider his work on Gothic and Greek art to be among his most significant

writings. For example, in his ground-breaking essay "Of German Architecture" (1772), Goethe described experiencing the Gothic cathedral of Strasbourg not as irrational and barbaric, as he had expected, but as beautiful and harmonious. Explaining the underlying order and geometry of Gothic style, Goethe broke not only with Vasari's widely accepted view of Gothic architecture as degenerate, but also implicitly with the birth–development–decline model of art history.

The nineteenth century: foundations of modern art history

In the nineteenth century, art historians developed several basic models to account for changing artistic styles. Some scholars engaged in what we might call social history, linking stylistic change to cultural change. Others argued that changes in artistic style were entirely internal to art-making, and owed nothing to outside forces. Still others argued that artistic style changed as styles became stale, so that artists enriched and elaborated on their predecessors in a constant process of innovation. All of these scholars, in one way or another, were concerned with systematizing the practice of art history.

For the German philosopher Georg Wilhelm Friedrich Hegel (1770–1831), art was a form of symbolism, a vehicle for ideas. Its principal historical function was to represent and articulate the Divine Idea in material form. In fact, Hegel saw all of history as one long process—the unfolding of the Divine Idea in this sensory (and therefore illusory) world. According to Hegel, the Divine Idea is unchanging, and its changing representations over time—that is, differing artistic styles—are only the confused ways in which human beings attempt to grasp unchanging divine perfection. Like Winckelmann, Hegel perceived the visual arts as a means by which a culture expressed and communicated its essential ideas. But where Winckelmann sought his explanation in various aspects of a people's history and experience, Hegel looked to the Divine Idea alone.

As influential as Hegel's work was, several scholars took up positions in opposition to his. The Swiss scholar Jacob Burckhardt (1818–1897) dismissed Hegel's idea that history follows a preordained path. Instead, he emphasized the importance of using empirical methods to reconstruct the past in detail. With his wide-ranging interests—he had studied theology, Greek, history, and art history—Burckhardt emphasized that the arts were of central importance in understanding the past. He took his cue from Winckelmann in studying art in its broad cultural context. But where Winckelmann developed a theoretical model for art history, Burckhardt refused to do so, and it was up to his successors to develop some of the ideas implicit in his work.

Following Burckhardt and Hegel, Alois Riegl (1858–1905) argued that universal laws governed the history of art and that each period is characterized by particular versions of those laws. Works carry the hallmark of their time because of the period's *Kunstwollen*, the "will to form" that arises from its version of those universal laws. Riegl's approach is particularly interesting today because he didn't make any distinction between "art" and "craft." He argued that any object, whether an inexpensive piece of stamped pottery or a magnificent cathedral altarpiece, can reveal the character of a particular age or culture. Riegl was also unusual in that he applied his method equally to works of art from many cultures, from ancient Rome to the Maori of New Zealand/Aotearoa. Unlike other art historians, who worked with the birth–development–decline model, Riegl didn't see any period as better or worse than any other—each was distinctive and worthy of study in its own right.

Like Riegl, the Swiss scholar Heinrich Wölfflin also sought universal principles that governed the history of art (see also pages 34–35 above). Trying to understand the process of stylistic change, Wölfflin argued that art develops according to a cycle of early, classic, and baroque phases. Wölfflin emphasized that he didn't mean that one of these phases was better than the others (although the positive connotations of the work "classic"

and the sometimes negative connotations of the word "baroque" cast some doubt on this assertion). Another one of Wölfflin's important insights was that an artist's style has roots both in previous art traditions and in the artist's own culture. For Wölfflin, the distinction between what an artist takes from previous art and what he takes from the culture of his times was very clear: visual style comes from other artists, iconography (symbols and motifs) from the artist's culture. Of course, these divisions don't seem quite so clear-cut to us today: why, after all, can't an artist take an iconographic element from another artist, or be inspired to use certain forms or colors by the culture that surrounds her?

Parallel to Wölfflin, two other scholars took up these formalist concerns. The Italian scholar Giovanni Morelli focused primarily on systematizing the method of attributing works of art to particular painters. Morelli relied on close and systematic observation of details. He demonstrated, for example, that painters have distinctive ways of painting the human ear and the thumbnail, and that these details can be used to identify artists. At the turn of the century, the French art historian Henri Foçillon (1881–1943) further developed the formalist tradition. Foçillon defined artistic style as the existence of coherence and harmony in both the visual properties and also the formal structures (syntax) of a group of artworks. Perhaps the easiest way to understand this idea is through language. Take, for example, two sentences: "The dog chewed the bone" and "The woman opened the door". They include variants on the same "forms" (nouns, verbs, articles), and, moreover, they have the same structure or syntax (subject–verb–object). Similarly, Gothic cathedrals all share the same forms (for example a cross-shaped plan, rib vaulting, and stained-glass windows) assembled in the same structural way. Sometimes, according to Foçillon, a single element, or "grammatical form," captures an artistic style—the Gothic rib vault was his prime example.

In a different vein, Wölfflin's contemporary Aby Warburg (1866–1929) took up Burckhardt's concern with

explaining in precise historical detail how works of art functioned spiritually, politically, and psychologically in their original contexts. Warburg focused on the study of particular symbols or motifs in fifteenth-century European art, especially in connection to literature. He treated a visual image like a text with a systematic, readable vocabulary. In isolating particular elements for interpretation, Warburg situated the work of art in a network of textual and visual representations, and fine arts and popular arts. As the founder of the Warburg Institute in London, he bridged the turn of the century and was a highly influential force in twentieth-century art history.

Twentieth-century formalists, iconographers, and social historians

In the twentieth century, the students and inheritors of the nineteenth-century traditions elaborated those traditions in a variety of ways and defined a distinctive method for art history. At the same time, art history broadened its scope through greater interaction with other academic disciplines, such as sociology and anthropology, and with theoretical perspectives such as Marxism and Freudian psychoanalysis.

Erwin Panofsky (1892–1968) is a figure of great importance to twentieth-century art history. After studying at Berlin and the University of Freiburg, he taught at Hamburg and worked with Aby Warburg and the philosopher Ernst Cassirer (1874–1945). In 1933 the Nazis removed him from his position, like so many other scholars, and he sought asylum in the United States, where he taught for many years. Panofsky is influential for developing the theory and method of iconography, which is the study of the subjects and motifs of art in relation to literature and previous traditions of artistic representation. Panofsky also elucidated the theory of iconology, which is a distinctive way of studying the larger philosophical and cultural attitudes informing an artwork. In one of his most subtle and original essays, for example, Panofsky argued that Renaissance perspective,

6.3 Ernst Gombrich's diagram of the *Volksgeist*.

constructed according to a single vanishing point, is a culturally rich concept, not simply a utilitarian way of representing space. This particular way of representing space makes connections between the viewer and the viewed (viewers see the "space" in the picture as continuous with their own space) and is thus a key to Renaissance theories of knowledge, of the connection between the knower and the known.

Ernst Gombrich (1909–2001) studied art history in his native Vienna, where he was influenced by the work of Riegl among others. He left Austria for England in 1936 before the Nazi occupation. Gombrich used insights from psychology to study the creation and perception of visual images. He was very interested in the functions of images in their social context—a phenomenon that he called "the ecology of art." He developed Hegel's idea that each period or culture has a distinctive spirit (*Volksgeist*) but without Hegel's metaphysical framework. Instead of each period representing the Divine Idea in different ways, Gombrich saw the *Volksgeist* as composed of different elements—art, science, religion, law, morality— arranged and interconnected like the spokes on a wheel (Figure 6.3).

Also in the mid-twentieth century, the social history of art emerged as a new trend in the discipline. The social historians of art focused not on connoisseurship, but on

socio-economic concerns, including art's function in society, the relationship between artist and patron, their motives for producing the work, and the reception of the work by a general audience. Unlike Panofsky's iconography or Gombrich's *Volksgeist*, the social history of art drew its inspiration from Marxist history as well as sociology. The social historians of art produced dense, factual studies of specific periods, institutions or individual works and avoided sweeping historical generalizations. One exception to this practice was Arnold Hauser's controversial *Social History of Art* (1951), which is, oddly enough, perhaps the best-known example of the social history of art. Hauser's wide-ranging survey of Western art links stylistic change and social change, and was heavily critiqued for over-generalizing. The social history of art, in its more specific form, continued to develop and inspired in many ways the work of a younger generation of art historians.

After 1970: the "new" art history

The "new" art history, practiced by scholars who largely began publishing in the 1970s, made some radical breaks with its immediate predecessors. The "new" art historians argued that the discipline was so involved in formal analysis and connoisseurship that it had become purely descriptive and a service industry to the art market. At the same time, they heavily critiqued scholars who unthinkingly followed Panofsky's iconography, with none of his subtlety or larger perspective. A major figure among the "new" art historians, T. J. Clark (b. 1943), scorned this kind of art history as "desultory theme-chasing."

Practitioners of the new art history, like Clark, Svetlana Alpers (b. 1936), and Norman Bryson (b. 1949), have challenged the discipline to engage with critical theory, with politics and ideology, with art in/as social context. In *Rembrandt's Enterprise: The Studio and the Market* (1988), for example, Alpers focused not on traditional issues of attribution, formal analysis, or iconography, but on Rembrandt as a successful businessman who shrewdly appealed to his consumers. The new art historians have

worked from a range of theoretical perspectives, engaging with Marxism, feminism, psychoanalysis, structuralism, and poststructuralism. As the humanities have become increasingly interdisciplinary, scholars from English, history, and other fields have begun to work in art history. Bryson and Mieke Bal (b. 1946), for example, were trained as literary theorists, but have made important contributions to art history. Both are particularly interested in the complex interrelations between images and texts, exploring the language-like qualities of visual images and developing processes for interpreting visual images that they liken to reading.

You may have noticed that most of the art historians discussed so far have been male. For centuries, the professions that wrote about art—those of artist, scholar, and critic—were typically closed to women. The formal practice of art history as an academic discipline since the eighteenth century also largely excluded women. There were some notable exceptions; in 1822, for example, the German novelist and scholar Johanna Schopenhauer (1766–1838) wrote one of the first studies on the artist Jan van Eyck. It was not until the twentieth century, however, with the mass entrance of women into universities and the workforce, that women scholars consistently began to make substantial contributions to art history.

Not surprisingly, several major women art historians have focused on the development of feminist art histories. Pioneering feminist art historians, including Linda Nochlin (b. 1931), Griselda Pollock (b. 1949), Mary Garrard, and Norma Broude, have not only worked to recuperate the work of unknown or forgotten women artists, like Artemisia Gentileschi, but they have also challenged the practice of the discipline itself. They consistently demonstrated that the kinds of questions traditionally asked about art have worked to exclude women artists. Pollock, for example, integrated a Marxist focus on politics and power in society with a feminist analysis of patriarchal social practices (that is, practices that put men in positions of power and exclude women). Her studies of artists like Mary Cassatt and Berthe

The feminist art-history revolution

Linda Nochlin's ground-breaking essay "Why Have There Been No Great Women Artists?" (1971) challenged the primacy of the white male perspective within art history as an intellectual distortion. She asserted that feminist art history wasn't just about "the woman problem"—it was about changing the very way that art history was conceptualized and practiced:

" It is the engaged feminist intellect (like John Stuart Mill's) that can pierce through the cultural-ideological limitations of the time and its specific "professionalism" to reveal biases and inadequacies not merely in dealing with the question of women, but in the very way of formulating the crucial questions of the discipline as a whole. Thus, the so-called woman question, far from being a minor, peripheral, and laughably provincial sub-issue grafted on to a serious, established discipline, can become a catalyst, an intellectual instrument, probing basic and 'natural' assumptions, providing a paradigm for other kinds of internal questioning, and in turn providing links with paradigms established by radical approaches in other fields . . .

'Why have there been no great women artists?' The question tolls reproachfully in the background of most discussions of the so-called woman problem. But like so many other so-called questions involved in the feminist 'controversy,' it falsifies the nature of the issue at the same time that it insidiously supplies its own answer: 'There are no great women artists because women are incapable of greatness.'

[. . .] But in actuality, as we all know, things as they are and as they have been, in the arts as in a hundred other areas, are stultifying, oppressive, and discouraging to all those, women among them, who did not have the good fortune to be born white, preferably middle class and, above all, male. The fault lies not in our stars, our hormones, our menstrual cycles, or our empty internal spaces, but in our institutions and our education . . . The miracle is, in fact, that given the overwhelming odds against women, or blacks, that so many of both have managed to achieve so much sheer excellence, in those bailiwicks of white masculine prerogative like science, politics, or the arts.

The question 'Why have there been no great women artists?' is simply the top tenth of an iceberg of misinterpretation and misconception . . . Basic to the question are many naïve, distorted, uncritical assumptions about the making of art in general, as well as the making of great art. These assumptions, conscious or unconscious, link together such unlikely superstars as Michelangelo and van Gogh, Raphael and Jackson Pollock under the rubric of 'Great' — an honorific attested to by the number of scholarly monographs devoted to the artist in question—and the Great Artist is, of course, conceived of as one who has 'Genius'; Genius, in turn, is thought of as an atemporal and mysterious power somehow embedded in the person of the Great Artist . . . To encourage a dispassionate, impersonal, sociological, and institutionally oriented approach would reveal the entire romantic, elitist, individual-glorifying, and monograph-producing substructure upon which the profession of art history is based, and which has only recently been called into question by a group of younger dissidents. "

Morisot (1841–1895) explore the ways in which their images of upper-class women in domestic settings reveal sexual difference as socially constructed, rather than innate or natural.

The next generation of feminist art historians has continued to explore the social construction of gender, challenging the idea of gender as a dualism (male/female, either/or), and expanding the range of art under consideration. Amelia Jones, for example, has written extensively about issues of gender in modern and contemporary art, including performance art as a way of representing the gendered body. Her book *Irrational Modernism: A Neurasthenic History of New York Dada* (2004) focuses on the figure of Baroness Elsa von Freytag-Loringhoven rather than the canonical trio of Marcel Duchamp, Man Ray, and Francis Picabia. Jones examines how the baroness lived and "performed" Dada through her flamboyant self-display. Like the pioneering feminist art historians, Jones uses this opportunity to challenge how art history does its work. She argues that scholars must take into account the marginal and "irrational," rather than simply exclude them from the canon of acceptable works they create. Closely related to this feminist work has been the development of a "queer" art history. Scholars have begun to recuperate the forgotten work of gay, lesbian, transgender, bisexual or queer artists and to analyze their work for homoerotic content. Like feminist art historians, these scholars challenge the ways in which art history asks questions about sexuality and gender identity, and how these factors intersect with race, ethnicity, and class—"queering" art history in the process. Jonathan Katz and Erica Rand are two art historians working in this vein.

When reading this chapter, you may have noticed that most of the art historians discussed in the previous sections focused on European art traditions, especially Classical and Renaissance art. With increasing global awareness, and greater interest in anthropology and other disciplines, art history over the past fifty years has widened its scope. The cultures of Africa, the Americas,

Asia, and the Pacific have begun to receive sustained scholarly attention. Like feminism, this scholarship has challenged some of the basic ways that art history has traditionally worked. Art historians like Suzanne Blier and Babatunde Lawal (b. 1942) for example, have emphasized the importance of engaging a variety of theoretical models in framing the interpretation of African art, including the conceptualization of the arts in indigenous terms. Blier's *African Vodun: Art, Psychology, and Power* (1995) and Lawal's *The Gelede Spectacle: Art, Gender, and Social Harmony in African Culture* (1997) are good examples. Scholars and curators Olu Oguibe (b. 1964) and Okwui Enwezor have both focused on contemporary African artists working in Western genres.

At the same time, art historians have broadened the notion of what constitutes art, and there is a new focus on images that can't be define as "high" art—that is, as art produced by highly trained artists. Art historians now study a range of practices variously called low, naïve, folk, vernacular, or popular art. Examples of this kind of art include embroidery made by medieval women, pottery made by African-American slaves, or contemporary photographic portraits of working-class immigrants. As these examples suggest, the people creating such works were typically not trained as professional artists, and were often marginalized in society by race, class, and gender. Scholar and artist David Driskell (b. 1931), for example, has written pioneering work on African-American artistic traditions.

Art historians are also increasingly interested in the analysis of what we might call art's institutions; that is, the museums, galleries, academies, universities, religious organizations, and publications where art is created, displayed, and discussed. The idea is that these institutions do as much to shape artistic practice as the individual artist does. Writing from Marxist perspectives, Carol Duncan and Allan Wallach did some of the pioneering work in this field, examining the political and ideological role of art museums in American society. They argued that museums help to shape national

identity and gender roles, and reinforce and create class boundaries. Annie E. Coombes has investigated the ways in which exhibitions of African art have shaped ideas about Africa in both colonial Britain (1890–1918) and in South Africa after apartheid.

Where will these innovations take art history in the future? These new ideas both challenge and reorient the practices of art history. It seems clear that art history will define itself less and less by stylistic change or period style and more by the interaction between art and society. It also seems clear that art historians will pursue an ever-widening variety of interests and deploy an ever-greater range of methodologies to do so. That art historians are increasingly aware of their own intellectual history, and the cultural and personal investments that underlie their ideas, points toward an art history that is simultaneously more personal and more deeply engaged with larger social and political contexts than in the past.

Do other cultures practice art history?

Art history today is internationally recognized as an academic discipline, practiced in universities and museums around the world. It is an interesting question whether non-Western cultures have their own traditions of art history; the answer is that, in fact, many do. Many other cultures, including China, Japan, India, and the Islamic world, have historically practiced a kind of analysis that asks many of the same questions as Western art history. In addition, many non-literate cultures have traditions of arts analysis and history, although they are less well documented in the absence of a written literature.

China

Writing about visual art in China began at least as early as the fourth century CE. Much like the writings of Pliny the Elder or Vasari, this early commentary on the arts mixed perspectives that we might recognize as belonging distinctly to art history, art criticism, connoisseurship, and aesthetics. Scholar-officials, who were required to practice calligraphy and often painted, primarily

Early art history in China

Xie He, a portraitist at the imperial court, composed the first surviving Chinese work on art, the *Gu huapin lu* (*Classification of Painters*). This is his introduction to the list of six grades of painters:

> The *Hua-p'in* (*Criticism of Painting*) is a book grading the skill and excellence of paintings. Paintings all teach us something about human conduct and past events. An age long past can be brought back before our eyes from its silence and obscurity. Few there are who can master all the six technical factors, but from ancient times till now, there have been artists who are good in some one aspect. What are these six techniques? First, creating a lifelike tone and atmosphere; second, building structure through brush-work; third, depicting the forms of things as they are; fourth, appropriate colouring; fifth, composition; and sixth, transcribing and copying. Only Lu T'an-wei and Wi Hsieh mastered all six. But there are individual differences in skill, and the laws of art apply to all ages. I have graded them according to their excellence, taking cognizance of their age, and have written this brief introduction. I have not tried to trace the origins of art. It is said that [art] came from the immortals. But nobody has seen them.

Guo Ruoxu's *Tuhua jianwen zhi* (*Experiences in Painting*) begins with general remarks on the art of painting, commenting on history and technique and making stylistic comparisons between individuals, periods, and regions. He then proceeds to tell anecdotes about famous painters:

> Huang Ch'üan. Wu Tao-tse once made a portrait of Chung K'uei [the subduer of devils]. The immortal was dressed shabbily, was blind in one eye, had the skin of one leg bruised, and his head was in a turban. A memorial tablet was stuck in his belt. His left hand held a devil while his right was gouging out the devil's eye. It was a most spirited drawing, one of the best ever done. Someone had presented this to the ruler of Szechuan. The latter loved it and used to hang it in his bedroom. One day he asked Huang Ch'üan to see it, and Huang praised it highly as a masterpiece. 'I want to see Chung K'uei plucking out the devil's eye with his thumb, which would be more effective. Please have it corrected for me.' Huang asked permission to take the painting home with him and contemplated it for several days and knew he could not do it. He therefore drew a new Chung K'uei plucking out the devil's eye with his thumb. The following day he presented both to the ruler. 'I asked you only to change it. Why did you draw another one?' asked the king. Ch'üan replied, 'In that one by Wu Tao-tse, the whole body of Chung K'uei, his look, his postured strength, are all concentrated in his index finger and not in the thumb. I could not possibly change it. So I have taken the liberty to do a separate one. I do not hope to equal the old master, but the strength of the whole body of this one is concentrated in the thumb.' The king admired it for a long time, and accordingly gave him presents of brocade and gilt ware as a sign of appreciation.

produced these works. Not surprisingly, their writings tended to focus on painting and calligraphy rather than architecture, sculpture, textiles, or ceramics. The first major work was the Gu huapin lu (*Classification of Painters*) by Xie He (?c. 500–35). It includes brief descriptions of individual artists and analyzes their artistic styles in terms of their personalities. In this work Xie He also developed a numerical grading system of talent and skill. His criteria for judging paintings, the Six *Laws of Painting*, strongly influenced later writers.

In some ways, Chinese commentators on the arts asked similar questions to those asked by Europeans— questions about the biographies of artists, the reception of works of art, the nature of techniques. In other ways the issues and concerns were very different. For example, the concept of *qiyun shengdong* (spirit consonance) doesn't have a counterpart in Western ways of talking about the arts. First recorded by Xie He, *qiyun shengdong* probably originally referred to the artist's ability to create a lifelike impression in the figures he painted. Eventually it was interpreted as a reflection of the artist's own spirit or personality in his painting.

One of the enduring concerns of writing about art in China was the comparative evaluation and ranking of artists. During the eleventh and twelfth centuries connoisseurs, basing themselves on earlier schemes by Xie He and others, consolidated a standard three-category ranking of painters: inspired, excellent, and competent. Within this framework writers documented and analyzed the differences between works based on school and geography.

Later periods saw the development of new models of writing about art. The most important text from the Tang period is Zhang Yanyuan's (?c. 815–c. 875) *Lidai minghua ji* (*Record of Famous Painters of All Periods*), which patterns itself on official Chinese dynastic histories. Although he discussed the origins and uses of painting in cosmological terms, Zhang also explained different stylistic traditions, painting techniques, and methods of connoisseurship. In the Song period, Guo Ruoxu

(?c. 1070) further developed this historical approach in his *Tuhua jianwen zhi* (*Experiences in Painting*, c. 1075). He used a systematic and precise vocabulary for the formal analysis of painting, identifying various kinds of brushstrokes and ink washes. A biographical framework was the foundation of Xia Wenyan's *Tuhui baojian* (*Precious Mirror for Examining Painting*, c. 1365), which is essentially a kind of biographical dictionary.

Writers continued to explore these different perspectives through the Ming and Qing dynasties, and China developed a tradition of art writings that was as strong and varied as its European counterpart. Dong Qichang (1555–1636) was a government official in the Ming dynasty and also a poet, calligrapher and painter (Figure 6.4). He adapted the formal language used to discuss form and expression in calligraphy to painting, including such paired terms as opening/closing, rising/falling, and void/solid. Dong's development of a systematic formal analysis for paintings can be compared to Wölfflin's some three centuries later. In the early twentieth century, Chinese scholars began to engage with Western modes of writing art history to create a new synthesis.

West Africa

Art historians tend to look for their working models in cultures that rely heavily on written language to pass on history and develop critical traditions, because our own culture is heavily reliant on written texts to do these things. But it's important to remember that there can be depth and richness in commentary on art in cultures where written language is absent, de-emphasized, or a relatively recent phenomenon. Since the 1970s, a number of art historians and anthropologists have worked hard to document and analyze discourses about art that occur in certain African cultures. Although many of these discourses around art are largely concerned with art criticism, they often also address historical issues. For

6.4 Dong Qichang, *The Qingbian Mountain*, 1617. Hanging scroll, ink on paper, 7 ft 3½ in × 26½ in (2.25 m x 67.2 cm). The Cleveland Museum of Art.

example, among the Yoruba of Nigeria, the work of the sculptor Olowe of Ise (active early 20th century), who carved for the palace of the *ogoga* (king) of Ikere, has been discussed and admired for decades. A song of praise, *oriki*, that honors Olowe and his artistic achievements is still sung in the region where he worked.

In fact, the Yoruba regard the evaluation of artworks as a kind of deep discourse, or *oro ijinle*. The Yoruba look for a number of well-established characteristics when evaluating art, including resemblance, clarity of line and form, shining smoothness of surface, balance, straightness, youthfulness, and composure. An artist is considered to be someone who has certain characteristics: he or she has insight, sensitivity to design and composition, an ability to capture the essential character of a thing or person, a sense of propriety, and the ability to innovate. These concepts and criteria underlie the appreciation and evaluation both of artists and of the performance of masks and masquerades.

Conclusion

Art history's own history may not seem immediately relevant as you make your way through beginning art-history classes, but a broader view of the discipline may give you a better perspective on your work. I hope that this short history has sparked your interest, and that you haven't found it as vexing or wearying as Jane Austen's Catherine Morland might have.

This is not a comprehensive glossary of art-historical terms, but simply a guide to the specialized terms used in this book. For more in-depth treatment of art historical terminology, consult James Smith Pierce's *From Abacus to Zeus: A Handbook of Art History* (Prentice Hall, 2000) or the Art and Architecture Thesaurus on the Getty Research Center Website (www.getty.edu).

ABSTRACT 1. A summary, typically of a book or journal article. 2. A non-figurative image, or one in which the figurative elements are de-emphasized.

AESTHETICS A branch of philosophy concerned with the nature of beauty and judgements about beauty.

CANON A set of standard works (of art, literature, scholarship, etc.), widely recognized for their importance.

CATALOGUE RAISONNÉE The complete catalogue of an artist's work, often including extensive entries on each work, tracing its collection history (provenance) and commenting on its significance.

COMPOSITION The structure or arrangement of the elements (form, line, color, etc.) in a work of art.

CONNOISSEURSHIP The evaluation and valuation of works of art, in terms of both artistic quality and monetary value.

CONTEXTUAL ANALYSIS The interpretation of a work of art in terms of its culture and period.

CONTRAPPOSTO A pose in which the body is twisted so that the hips, shoulders, and head turn in different directions but balance each other.

CORPUS (PL. CORPORA) From the Latin term for "body," a *corpus* publishes all the objects of a known type.

DISCOURSE A tradition of discussion on a subject.

EKPHRASIS A form of rhetoric that presents a vivid description of works of art, trying to evoke their presence in the mind of the listener or reader.

ELEVATION A view of the interior and/or exterior of a building from the side.

ENDNOTE A citation that appears at the end of a paper or article, numbered in the text in superscript.

EPHEMERAL Not enduring, but short-lived, such as artwork made of leaves or flowers.

FESTSCHRIFT A collection of essays celebrating a famous scholar (often upon retiring). Students and colleagues contribute essays that often address, or were inspired by, the honoree's work.

FIGURATIVE Depicting a recognizable form or figure; the opposite of abstract.

FOLK ART Art made by ordinary people who have no particular training as artists.

FOOTNOTE A citation that appears at the bottom of a page, numbered in the text in superscript.

FORMAL ANALYSIS The interpretation of a work of art through its visual or material aspects, not its context.

FRONTAL/FRONTALITY Made to be seen straight on, by a viewer standing in front of the work

"HIGH" ART Art made by individuals with extensive training as artists and falling into the categories of

painting, sculpture, drawing, or architecture.

HUE A characteristic of color that refers to its position in the spectrum.

ICONOGRAPHY The study of the symbols and motifs in a work of art, by relating their representation in the work to their representation in literature and other works of art.

ICONOLOGY The study of the larger philosophical and cultural attitudes informing a work of art.

ILLUSIONISM An appearance of reality in a work of art.

IMPASTO Paint thickly applied to a surface.

INTERDISCIPLINARY Involving the perspectives of two or more academic, scientific, or artistic disciplines.

LINEAR/LINEARITY A composition that emphasizes lines over shading or contouring to create a sense of form.

"LOW" ART Art made by and for people without specialized artistic training or elite status.

MASS Indicates whether an artwork conveys a sense of substantial form—as if it has weight and volume.

MIMESIS Imitation; a term used by Plato to describe the art of sculpture and painting.

MINARET A tower on the exterior of a mosque from which worshippers are called to prayer.

MONOGRAPH A book that focuses on the work of a single artist.

MOSQUE A building dedicated to communal public worship in the Islamic tradition.

NEGATIVE SPACE A defined but empty space in architecture, sculpture, or painting that is nonetheless an important part of the composition.

PAINTERLY An image in which forms are defined by tone, color, light and dark, rather than line.

PARENTHETICAL REFERENCE A citation in the sentence or paragraph, including, typically, the author's last name, publication date, and page number.

PATRON An individual or institution that sponsors the creation of a work of art.

PERSPECTIVE Systems of representing the illusion of objects in space in a two-dimensional artwork. In linear perspective, orthogonal lines (which run into space at right angles to the picture plane) converge toward one or more vanishing points. In atmospheric or aerial perspective, distant things are depicted with less detail and clarity, and by shifting colors toward blue hues and decreasing their saturation and contrast.

SATURATION The intensity, or relative brightness or dullness, of a color.

SCHOOL A group of artists from a particular period who share similar styles and ideas.

SECTION An imaginary vertical slice through a building that shows both its exterior silhouette and the internal arrangement of spaces.

THESIS The main idea of an argument.

TYMPANUM The area above a doorway in medieval church architecture.

VALUE The relative degree of light and dark in a color or in a work of art.

Writing guides for students

Amato, Carol J. *The World's Easiest Guide to Using the MLA: A User-Friendly Manual for Formatting Research Papers According to the Modern Language Association Style Guide.* Stargazer Publishing Company, 1999.

Barnet, Sylvan. *A Short Guide to Writing About Art*, 6th ed. Addison-Wesley, 1999.

Gibaldi, Joseph. *MLA Handbook for Writers of Research Papers*, 5th ed. Modern Language Association, 1999.

Sayre, Henry M. *Writing about Art*, Upper Saddle River: Prentice Hall, 1998.

Strunk, William Jr., E.B. White, Charles Osgood, Roger Angell. *The Elements of Style*, 4th ed. Allyn & Bacon, 2000.

Trimmer, Joseph F. *The Essentials of MLA Style: A Guide to Documentation for Writers of Research Papers, with an Appendix on APA Style.* Boston: Houghton Mifflin Co., 1998.

Turabian, Kate L. *A Manual for Writers of Term Papers, Theses, and Dissertations.* Chicago: University of Chicago Press, 1996.

Periodicals

African Arts	*Art in America*
American Art	*Artnews*
American Indian Art	*Art Nexus*
Apollo	*The Burlington Magazine*
Archives of Asian Art	*Gesta*
Art Asia Pacific	*History of Photography*
The Art Book	*Journal of Aesthetics and Art Criticism*
The Art Bulletin	*The Metropolitan Museum of Art Bulletin*
Art Criticism	*Orientations*
Artforum International	*Oxford Art Journal*
Art Journal	*Simiolus*
Art History	*Source*

Websites

Websites become outdated quickly, but these were all up and running as this book went to press:

Hubs

Art and Architecture Mainly from the Mediterranean Basin, http://rubens.anu.edu.au/
Art History Resources on the Web, http://witcombe.sbc.edu/ARTHLinks.html
ArtSource, www.ilpi.com/artsource/welcome.html
The Mother of All Art History Links, http://www.art-design. umich.edu/mother/

Specialized sites

The American Museum of Photography, www.photographymuseum.com
Art & Architecture Thesaurus, www.getty.edu/research/conducting_research/vocabularies/aat/

Art & Life in Africa Online, www.uiowa.edu/africart/toc/
The British Museum, www.thebritishmuseum.ac.uk
The Guggenheim Museum, www.guggenheim.org
Heard Museum, www.heard.org
The Library of Congress, www.loc.gov
The Louvre, www.louvre.fr
The Metropolitan Museum of Art, www.metmuseum.org
The Museum of Modern Art, www.moma.org
National Museum of the American Indian, www.nmai.si.edu/
Smithsonian Institution, www.si.edu
Vatican Museum, mv.vatican.va

General guides and reference works

Chilvers, Ian, Harold Osborne, Dennis Farr, eds. The Oxford Dictionary of Art. New
 York: Oxford University Press, 1997.
Mayer, Ralph. The Harper Collins Dictionary of Art Terms and Techniques, 2nd ed.
 Harperperennial Library, 1995.
Murray, Peter, and Linda Lefevre Murray. Penguin Dictionary of Art and Artists, 7th
 ed. Penguin, 1998.
Pierce, James Smith. From Abacus to Zeus: A Handbook of Art History, 6th ed. Upper
 Saddle River: Prentice Hall, 2000.
Read, Herbert, ed. The Thames and Hudson Dictionary of Art and Artists. New York:
 Thames & Hudson, 1994.
Turner, Jane, ed. The Grove Dictionary of Art. New York: Macmillan, 1996.

Art history's theory and methodology

Adams, Laurie Schneider. The Methodologies of Art: An Introduction. New York:
 Icon Editions, 1996.
Berger, John. Ways of Seeing. London: Penguin, 1979.
Elkins, James. Stories of Art. New York; London: Routledge, 2002.
Nelson, Robert S. and Richard Shiff. Critical Terms for Art History. Chicago:
 University of Chicago Press, 1996.
Pointon, Marcia R. History of Art: A Students' Handbook. With the assistance of
 Lucy Peltz. 4th ed. London: Routledge, 1997.

History of art history — general

Barasch, Moshe. Theories of Art from Plato to Winckelmann. New York: New York
 University Press, 1985.
Fernie, Eric. Art History and its Methods: A Critical Anthology. London: Phaidon
 Press Ltd., 1995.
Harrison, Charles et al ed. Art in Theory: An Anthology of Changing Ideas. Vols 1–3,
 Malden, Mass; Oxford: Blackwell Publishers, 1998–2003.
Holt, Elizabeth Gilmore ed. A Documentary History of Art. Vols 1–3. Princeton, N.J.:
 Princeton University Press, 1981–86.
Minor, Vernon Hyde. Art History's History. Upper Saddle River: Prentice Hall, 2001.

Podro, Michael. *The Critical Historians of Art*. New Haven: Yale University Press, 1982.

Preziosi, Donald, ed. *The Art of Art History: A Critical Anthology*. New York: Oxford University Press, 1998.

Writings on art from antiquity, the Middle Ages, and the Renaissance

Eco, Umberto. *Art and Beauty in the Middle Ages*, transl. H. Bredin. New Haven: Yale University Press, 1986.

Pliny the Elder. *Naturalis Historia/Natural History*, transl. John F. Healy. New York: Penguin Books, 1999.

Suger, Abbot of Saint Denis. *Abbot Suger on the Abbey Church of St. Denis and its Art Treasures*. Ed. Erwin Panofsky. Princeton, N.J.: Princeton University Press, 1979.

Vasari, Giorgio. *The Lives of the Artists*, transl. Julia Conaway Bondanella, Peter Bondanella. New York: Oxford University Press, 1998.

Eighteenth-century writings on art

Gage, John, ed. *Goethe on Art*. Berkeley: University of California Press, 1980.

Kant, Immanuel. *The Critique of Judgement*. Translated with analytical indexes by James Creed Meredith. Oxford, New York: Clarendon Press, 1973.

Potts, Alex. *Flesh and the Ideal: Winckelmann and the Origins of Art History*. New Haven: Yale University Press, 1994.

Nineteenth-century art history

Burckhardt, Jacob. *Reflections on History*, transl. M.D. Hottinger. Indianapolis: Liberty Classics, 1979.

Gombrich E.H. *Aby Warburg: An Intellectual Biography, with a Memoir on the History of the Library of F. Saxl*, 2nd ed. Chicago: University of Chicago Press, 1986.

Hegel, Georg Wilhelm Friedrich. *The Philosophy of Fine Art*, transl. F.P.B. Osmaston, 4 vols. New York: Hacker Art Books, 1975.

Iversen, Margaret. *Alois Riegl: Art History and Theory*. Cambridge: MIT Press, 1993.

Wölfflin, Heinrich, *Classic Art; an Introduction to the Italian Renaissance*, 3rd ed. New York: Phaidon, 1968.

———— *Principles of Art History: The Problems of the Development of Style in Later Art*, transl. M.D. Hottinger. New York: Henry Holt, 1932.

Twentieth-century art history

Foçillon, Henri. *The Life of Forms in Art*. New York: Zone Books, 1989.

Hauser, Arnold. *The Social History of Art*, 4 vols. New York: Routledge, 1999.

Panofsky, Erwin. *Meaning in the Visual Arts*. Chicago: University of Chicago Press, 1982.

Schapiro, Meyer. *Theory and Philosophy of Art: Style, Artist, and Society*. New York: George Braziller, 1994.

Woodfield, Richard, ed. *The Essential Gombrich: Selected Writings on Art and Culture*. London: Phaidon Press, 1996.

"New" and current art history

Alpers, Svetlana. *The Art of Describing: Dutch Art in the Seventeenth Century*. Chicago: University of Chicago Press, 1983.

Belting, Hans, *The End of the History of Art?*, transl. Christopher S. Wood. Chicago: University of Chicago Press, 1987.

Blier, Suzanne Preston. *African Vodun: Art, Psychology, and Power*. Chicago: University of Chicago Press, 1995.

Bryson, Norman. *Vision and Painting: The Logic of the Gaze*. New Haven: Yale University Press, 1983.

Cheetham, Mark A., Michael Ann Holly, and Keith Moxey, eds. *The Subjects of Art History: Historical Objects in Contemporary Perspectives*. Cambridge: Cambridge University Press, 1998.

Harris, Jonathan. *The New Art History: A Critical Introduction*. London: Routledge, 2001.

Kampen, Natalie Boymel et al., eds. *Sexuality in Ancient Art: Near East, Egypt, Greece, and Italy*. Cambridge: Cambridge University Press, 1996.

Kaufmann, Thomas Dacosta. "What is 'New' about the New Art History?" in Philip Alperson, ed., *The Philosphy of the Visual Arts*. New York: Oxford University Press, 1992, 515–20.

Nochlin, Linda. *Women, Art, and Power: and other essays*. New York: Harper & Row, 1988.

———— *Representing Women*. New York: Thames & Hudson, 1999.

Pollock, Griselda. *Vision and Difference: Femininity, Feminism, and Histories of Art*. New York: Routledge, 1988.

———— *Differencing the Canon: Feminist Desire and the Writings of Art's Histories*. New York: Routledge, 1999.

History of museums

Greenberg, Reesa, Bruce W. Ferguson, and Sandy Nairne, eds. *Thinking About Exhibitions*. New York: Routledge, 1996.

Hooper-Greenhill, Eilean. *Museums and the Shaping of Knowledge*. New York: Routledge, 1992.

Karp and Steven D. Levine, eds. *Exhibiting Cultures: The Poetics and Politics of Museum Display*. Washington, DC: Smithsonian Institution Press, 1991.

Art criticism

Carrier, David. *Artwriting*. Amherst: University of Massachusetts Press, 1987.

Frueh, Joanna, et al., eds. *New Feminist Criticism: Art, Identity, Action*. New York: Icon Editions, 1994.

Gayford, Martin and Karen Wright. *The Penguin Book of Art Writing*. New York: Viking, 1998.

Thompson, Richard Farris. "Yoruba Artistic Criticism" in Warren L. d'Azevedo, ed., *The Traditional Artist in African Societies*. Bloomington: Indiana University Press, 1973, 19–61.

Cultural studies and material culture studies

Carson, Fiona, and Claire Pajaczkowska, eds., *Feminist Visual Culture*. New York, Routledge, 2001.

Evans, Jessica, and Stuart Hall, eds., *Visual Culture: The Reader*. Corwin Press, 1999.

Glassie, Henry. *Material Culture*. Bloomington: Indiana University Press, 1999.

Hall, Stuart, *Representation: Cultural Representations and Signifying Practices*. London: Sage Publications, 1990.

Kingery, W. David. *Learning from Things: Method and Theory of Material Culture Studies*. Washington, DC: Smithsonian Institution Press, 1996.

Mirzoeff, Nicholas, ed. *The Visual Culture Reader*. New York: Routledge, 1998.

Williams, Raymond. *Culture and Society, 1780–1950*. Harmondsworth: Penguin, 1963.

Anthropology and sociology of art

Adorno, Theodor. *Aesthetic Theory*. Minneapolis: University of Minnesota Press, 1997.

Chaplin, Elizabeth. *Sociology and Visual Representation*. New York: Routledge, 1994.

Clifford, James. *The Predicament of Culture: Twentieth-century Ethnography, Literature, and Art*. Cambridge: Harvard University Press, 1988.

Coote, Jeremy and Anthony Shelton, eds. *Anthropology, Art and Aesthetics*. Oxford: Oxford University Press 1992.

Layton, Robert. *The Anthropology of Art*. New York: Cambridge University Press, 1991.

Zolberg, Vera L. *Constructing a Sociology of the Arts*. Cambridge: Cambridge University Press, 1990.

Arts of Africa, Asia, Oceania and the Americas

Abiodun, Roland; Drewal, Henry; and Pemberton, John. *Yoruba: Nine Centuries of African Art and Thought*. New York: Center for African Art, 1989.

——— *The Yoruba Artist: New Theoretical Perspectives in African Art Studies*. Washington, DC: Smithsonian Institution Press, 1994.

Heth, Charlotte et al. *Treasures of the National Museum of the American Indian*. New York; London, 1996.

Irwin, Robert. *Islamic Art in Context: Art, Architecture, and the Literary World*. New York: Harry N. Abrams, 1997.

Phillips, Tom, ed. *Africa, The Art of a Continent*. New York: Prestel, 1995.

Thomas, Nicholas. *Oceanic Arts*. London: Thames and Hudson, 1995.

Yutang, Lin. *The Chinese Theory of Art*. New York: G.P. Putnam's Sons, 1967.

Miscellaneous

Dening, Greg. *Readings/Writings*. Melbourne: Melbourne University Press, 1999.

Turner, Nicholas. *Florentine Drawings of the Sixteenth Century*. London: British Museum Publications, 1986.

Table of parallel illustrations in art-history surveys

Note Numbers in brackets [] denote a comparable, though not identical work.

H/F Hugh Honour and John Fleming, *A World History of Art*, Seventh Edition.
Janson H. W. and Anthony F. Janson, *History of Art*, Sixth Edition.
Stokstad Marilyn Stokstad, *Art History*, Revised Second Edition.
Gardner Helen Gardner, *Gardner's Art Through the Ages*, Twelfth Edition.
Adams Laurie Schneider Adams, *Art Across Time*, Second Edition.

	H/F	Janson	Stokstad	Gardner	Adams
Chapter 1: Introducing art history					
1.1 Barbara Kruger, *Untitled (You Invest in the Divinity of the Masterpiece)*, 1982	22.23	[28.18]	[29.77]	34.62	n/a
1.2 Harriet Powers, Bible Quilt, c. 1886	[22.24]	[25.44]	[24.15]	34.66	n/a
Chapter 2: Formal analysis					
2.2 Audrey Flack, *Marilyn (Vanitas)*, 1977	n/a	[24.79]	n/a	34.34	n/a
2.3 Francisco de Goya, *The Sleep of Reason Produces Monsters*, 1796–1798	[15.9]	21.22	27.16	28.41	[20.15]
2.4 Käthe Kollwitz, *Self-portrait*, 1921	[19.12]	[24.48]	[28.10]	[33.41]	[24.11]
2.5 Rembrandt, *Self-portrait*, 1630	[13.33]	[18.18]	[19.57]	[24.47]	[17.41–3]
2.6 Michelozzo, Palazzo Medici-Riccardi, begun 1444	10.20–21	12.21	17.38	21.20	n/a
2.7 Frank Lloyd Wright, Robie House, 1907–09	19.43–44	26.1–2	28.39	33.66	25.29
2.8 The mother goddess, Coatlique. Aztec, 15th century	12.16	n/a	23.5	30.4	[w5.18, w5.21]
2.9 Giovanni da Bologna, *Apollo*, 1573–5	11.63	[14.21]	[18.56]	[22.48]	[15.9]
2.10 Barbara Hepworth, *Three Forms*, 1935	n/a	[25.20]	n/a	33.70	n/a
2.11 Nam June Paik, *Electronic Superhighway*, 1995	n/a	[28.10]	29.97	[34.76]	n/a
2.14 Porcelain flask with blue underglaze. Ming, c. 1425–35	[12.69]	n/a	21.7	[26.4]	n/a
Chapter 3: Contextual analysis					
3.1 Sinan, Selimiye Mosque, 1567–74	12.39	n/a	[8.12]	13.20–22	9.10
3.3 Photograph of church interior, Florence	[9.21]	[11.30]	[16.28]	[17.6]	[11.28]
3.4 Power figure (*nkisi nkonde*), 19th century	[18.39]	n/a	25.9	32.5	n/a
3.6 Jan Van Eyck, *Arnolfini Wedding*, 1434	n/a	15.8–9	17.14	20.13–14	13.69

	H/F	Janson	Stokstad	Gardner	Adams
Chapter 4: Writing art-history papers					
4.2 Seated Couple. Dogon, 19th century	n/a	n/a	n/a	32.6	n/a
4.2 Gislebertus, tympanum depicting the Last Judgement, c. 1130	9.26	10.24	15.12–13	17.25	10.25
4.3 Vishnu Narayana, c. 530	6.27	n/a	9.20	6.19	w6.12
4.4 Artemisia Gentileschi, *Judith and her Maidservant Slaying Holofernes*, c. 1620	13.11	[17.4]	[19.19]	24.21	17.30
Chapter 5: Navigating art-history examinations					
5.1 Frieda Kahlo, *The Two Fridas*, 1939	20.20	[24.44]	28.85	33.49	[26.30]
5.2 Menkaure and Khamerernebty, c. 2500 BCE	2.37	2.14	3.12	3.13	3.18
5.3 Stela of Hammurabi, c. 1760 BCE. Basalt	2.14	3.16, detail	2.18	2.16	2.21
5.4 Akhenaten and his Family, 1348–1336 BCE	n/a	2.27	3.33	3.35	3.39
5.5 Colossal Statue of Constantine, 325–26 CE	n/a	7.45	6.82	10.78	7.52
5.6 Adelaide Labille-Guiard, *Self Portrait with Two Pupils*, 1785	n/a	n/a	26.47	n/a	n/a
5.7 Shrine at Ise, 1st century CE	6.111	n/a	11.5	8.5	n/a
5.8 Temple of Horyu-ji, 7th century CE	6.113	n/a	11.6	8.6	w6.6
Chapter 6: Art history's own history					
6.2 Hagesandrus, Polydorus, and Athenodorus, *Laocoön and his Two Sons*, 1st century CE	5.53	5.76	5.77	5.89	5.73–74
6.4 Dong Qichang, *The Qingbian Mountain*, 1617	[12.81]	n/a	21.11	26.11	n/a

Index

Page numbers in **bold** refer to illustrations

Photo credits